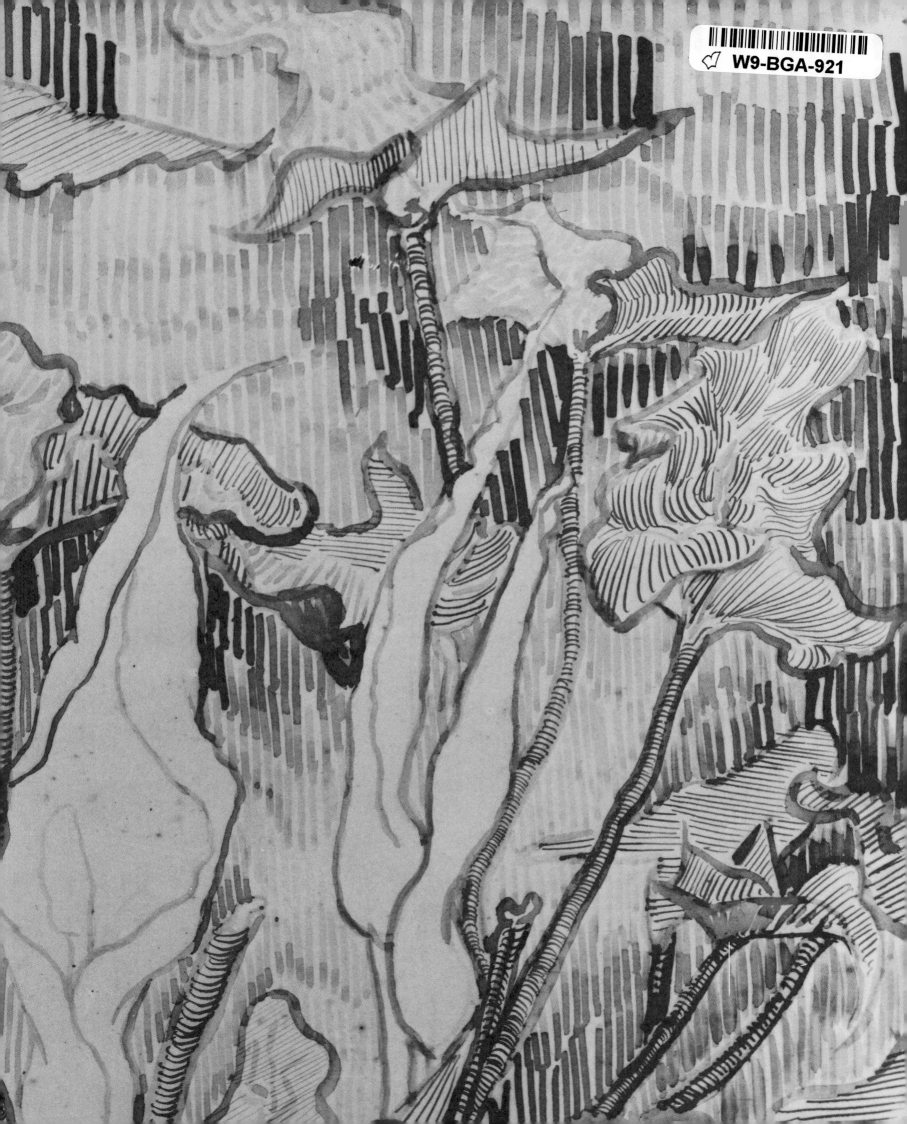

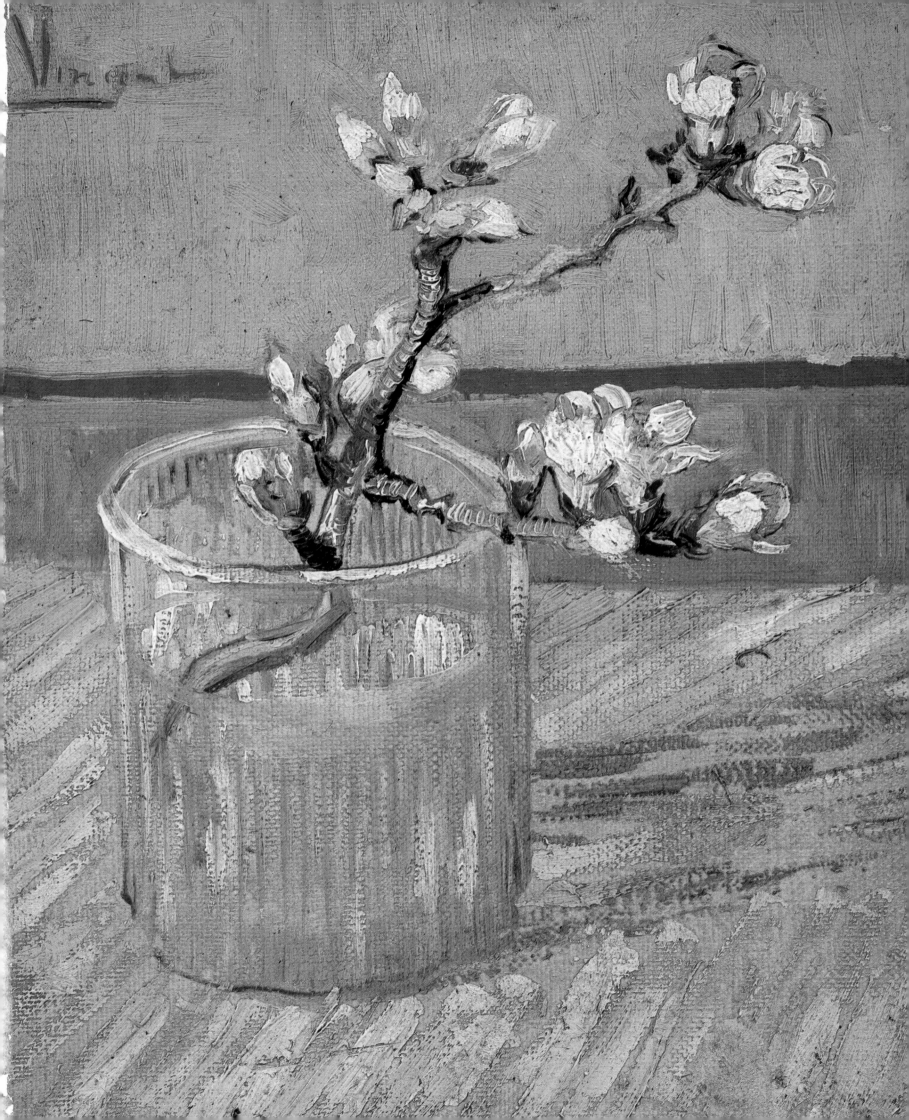

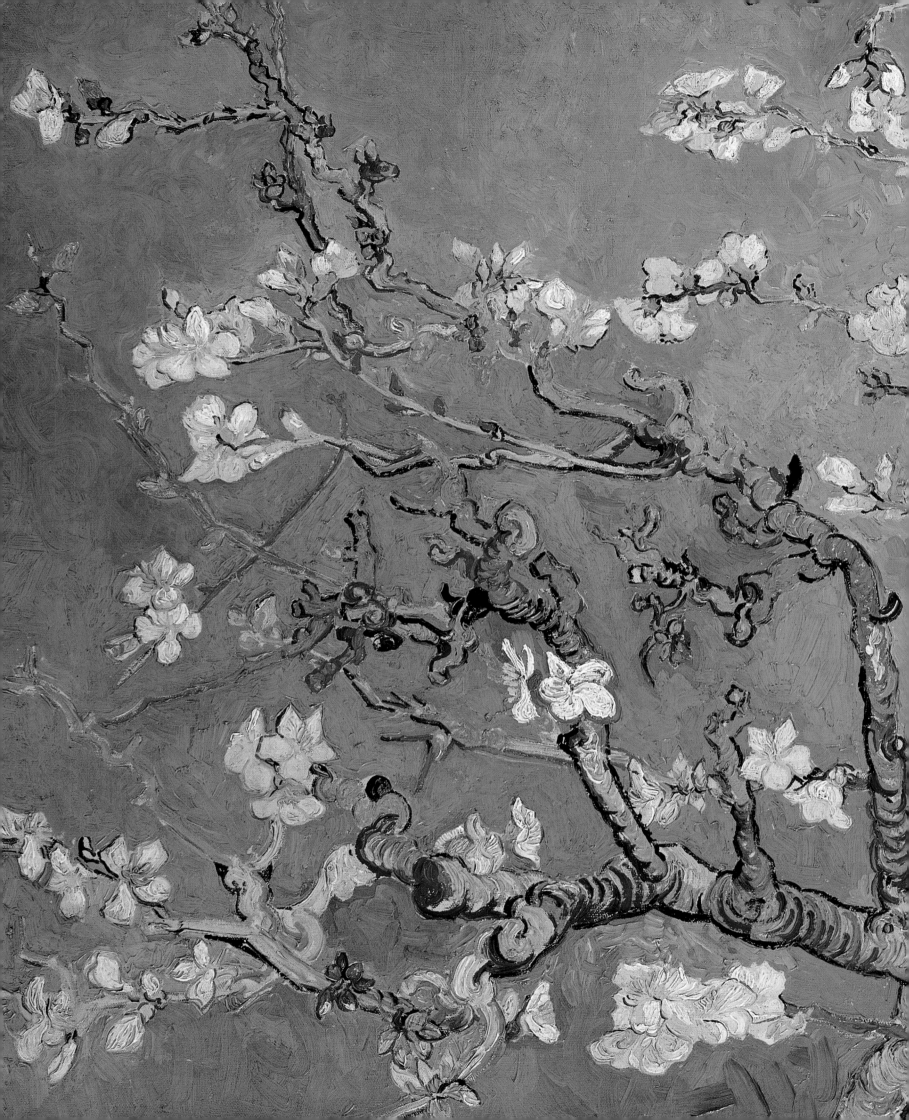

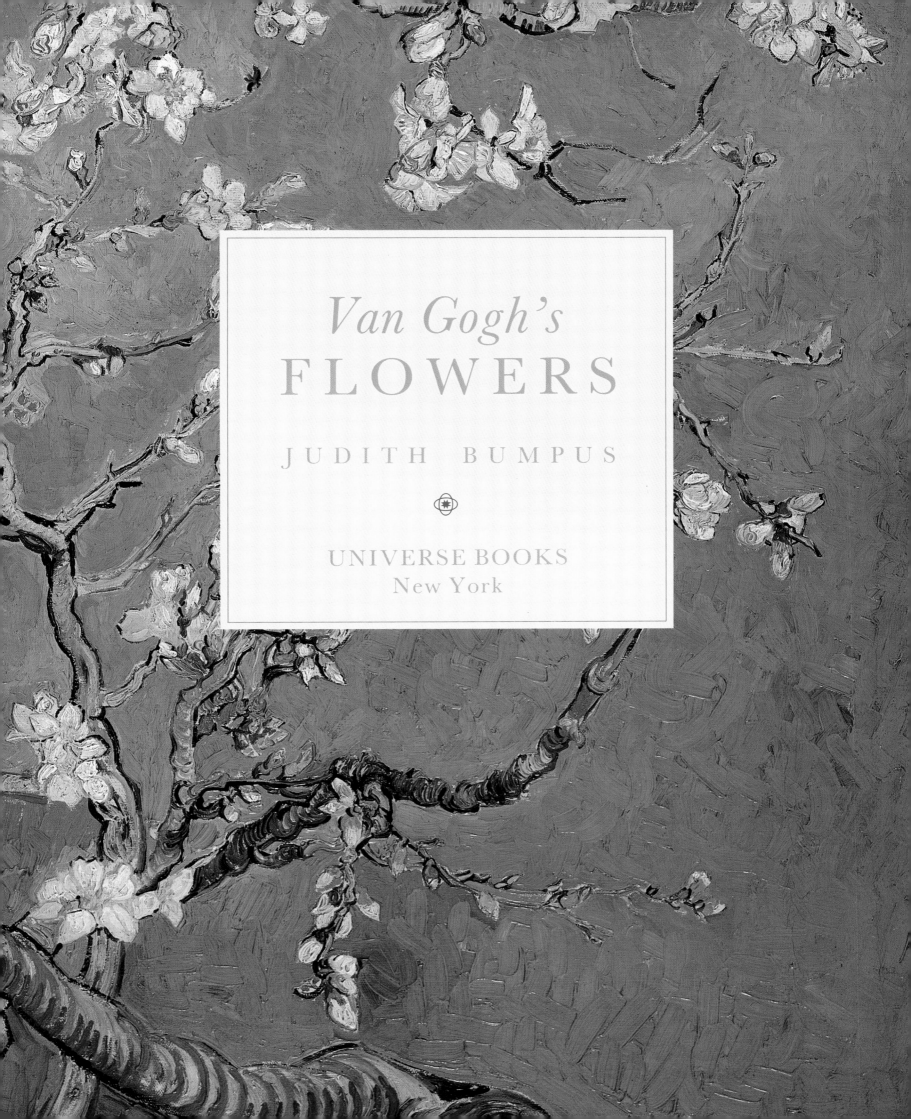

Van Gogh's
FLOWERS

JUDITH BUMPUS

UNIVERSE BOOKS
New York

To my parents, Robert and Mary Collison

Published in the United States of America in 1989 by Universe Books
381 Park Avenue South, New York, NY 10016

89 90 91 92 93 / 10 9 8 7 6 5 4 3 2 1

Printed in West Germany by Mohndruck Graphische Betriebe GmbH, Gütersloh

Library of Congress Cataloging-in-Publication Data

Bumpus, Judith.
 Van Gogh's flowers / Judith Bumpus.
 p. cm.
 Includes index.
 ISBN 0-87663-696-2
 1. Gogh, Vincent van, 1853-1890. 2. Flowers in art. I. Title
ND653.G7A4 1989a
759.9492--dc 19 89-30842
 CIP

Note
Van Gogh's letters quoted in this text have been taken from *The Complete Letters of Vincent
van Gogh*, 1958 (*see* p.80). They are all from the artist to his brother Theo unless stated
otherwise.

(*endpapers*) *Arums*. 1889. Pen, reed pen and brown ink, 31 × 41 cm (12^1/$_4$ × 16^1/$_8$ in).
National Museum Vincent van Gogh, Amsterdam, F1613 JH1703

(*half-title page*) 1 *Blossoming Almond Branch in a Glass*. 1888. Oil, 24 × 19 cm (9^1/$_2$ × 7^1/$_2$ in).
National Museum Vincent van Gogh, Amsterdam, F392 JH1361

(*title page*) 2 *Branches of an Almond Tree in Blossom* (detail). 1890. Oil, 73 × 92 cm (28^3/$_4$ × 36^1/$_4$ in).
National Museum Vincent van Gogh, Amsterdam, F671 JH1891

(*opposite*) 3 *Vase with Hollyhocks*. 1886. Oil, 94 × 51 cm (37 × 20^1/$_8$ in).
Kunsthaus, Zurich, F235 JH1136

(*pp.6-7*) 4 *Four Cut Sunflowers, One Upside Down*. 1887. Oil, 60 × 100 cm (23^5/$_8$ × 39^3/$_8$ in).
State Museum Kröller-Müller, Otterlo, F452 JH1330

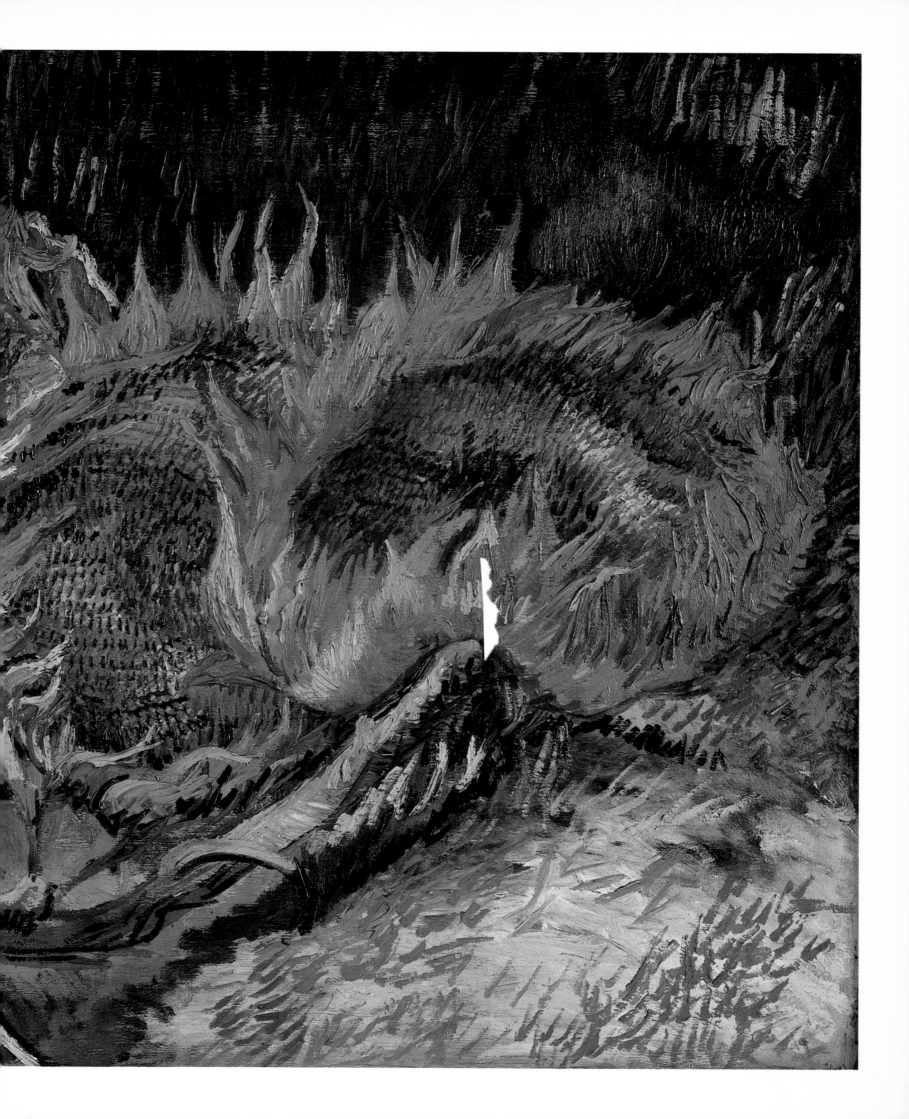

5 PAUL GAUGUIN (1848-1903): *Van Gogh Painting Sunflowers*. 1888.
Oil, 73 × 92.5 cm (28³/₄ × 36¹/₂ in).
National Museum Vincent van Gogh, Amsterdam

Van Gogh

&

THE GREAT BOOK OF NATURE

'A work of art is a corner of nature seen through a temperament.'
(ÉMILE ZOLA, *Mes Haines*, 1866)

Van Gogh's paintings of Provençal sunflowers, like blazing circles of energy and joy, will surely remain his most popular and inspiring images. He himself spoke of his special affinity with a flower whose rich colour typified the character of the South: 'that sulphur-yellow everywhere the sun lights'. His glorious paintings were emblematic of his gratitude for the happiness and serenity he found there. To his friend Paul Gauguin the sight of them was a revelation: 'That – it's – the flower,' van Gogh reported him as saying. These words must have rung as highest possible praise in van Gogh's ears; he had dedicated the whole of his short career to a study of nature, struggling to give it powerful and palpable expression. For today's audience it is Gauguin's portrait of him, at work on a vase of large sunflower heads placed beside his easel, that has come to epitomize this aspiration. As Gauguin imagined him, van Gogh sits rapt in his vision of the flowers. His gaze is fixed on the subject as, 'charged with electricity', he transmits it directly, almost instinctively, from eye through outstretched arm to canvas.

Van Gogh was proudly aware that he had revealed something new in his depiction of the sunflower: 'The sunflower is mine in a way,' he said. By sheer persistence of observation he had absorbed its nature so completely that he was able to render it unhesitatingly and with a freedom of interpretation that was entirely personal. The symbolic meaning attached to van Gogh's sunflowers has added to their appeal, but his paintings of irises, roses and almond blossom, among many others, show the same vigour of conception, and sparkle with similar freshness and conviction.

Many of his flower pictures were painted in series while the season for their blooming lasted and, as he related in the remarkably preserved correspondence he had with his younger brother, Theo, they provided him with colourful and ever-changing subject-matter: wild flowers among corn, flowering gardens and blossoming orchards, meadows of poppies and buttercups, branches of lilac, acacia, oleander and flowering chestnut. But for all their profusion, flowers were only one aspect of his love for nature in all her appearances, moods and weathers. Earth and sky, air, sun and stars, mountains, fields and trees, ears of wheat, dusty wayside thistles and blades of grass, farm animals, birds and nests, butterflies, moths and beetles were all, for him, part of the intrinsic beauty of creation, central to which was man.

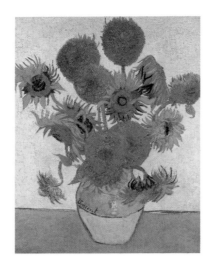

Van Gogh's vision of the world was aroused at an early age, moulded partly by his highly sensitive awareness of nature, partly by his pious upbringing. He was born in 1853, the eldest son of a minister of the Dutch Reformed Church, and several of his images, notably those of the sower and the reaper in the cornfield and of olive orchards, alluded to biblical stories. Even after he had lost his faith in formal religion, his temperamental inclination to ecstasy lent fervent expression in his art to a sense that beauty was a quality both supranatural and eternal. 'You need a certain dose of inspiration, a ray from on high, that is not in ourselves, in order to do beautiful things,' he confided to Theo (Letter 625, February 1890).

According to one of his sisters, van Gogh loved flowers, birds and insects as a boy and impressed his family with competent copies of plants, flowers and wooded landscape. His first excited discoveries were made in the garden attached to his father's village parsonage in Zundert and in the countryside beyond. It was there, walking through the wheatfields, pines and heathland of Brabant, that he also became conscious of the calming and restorative power of nature. The impression of those childhood years touched him so deeply that some twenty years on, writing to Theo from hospital in Arles, he was able to recall the scene with utmost clarity: 'During my illness I saw again every room in the house at Zundert, every path, every plant in the garden, the views of the fields outside, the neighbours, the graveyard, the church, our kitchen garden at the back – down to a magpie's nest in a tall acacia in the graveyard.' (Letter 573, January 1889)

The mood of reminiscence spoke of something more than nostalgia for the past and for happier times. His strong desire to reclaim his roots in Brabant sprang from a vision, shared by contemporary realist painters, in which 'true civilization' was life lived in harmony with nature. In a letter to his parents, van Gogh wrote: 'In my opinion a simple farmer *who works, and works intelligently*, is *the* civilized man.... In the city one finds a few men who are almost as noble, though in quite a different way, among the very, very rare excellent people.... In general there is more chance of finding a reasonable human being in the country than in the city....the nearer one gets to the large cities, the further one gets into the darkness of degeneration and stupidity and wickedness.' (Letter 334, October 1883)

6 *Fourteen Sunflowers in a Vase.* 1888.
Oil, 93 × 73 cm (36⅝ × 28¾ in).
National Gallery, London, F454 JH1562

Anchoring his own emotional leanings in the theories and arguments of the day, van Gogh held that familiarity with a place was essential if man was to gain material as well as spiritual sustenance from his surroundings. The peasants were able to draw benefit because, by their very being, they already seemed a product of the land: '*They remind one of the earth*, sometimes they seem modelled in it,' he wrote (Letter 406, May 1885). In order to convey the reality of their lives, van Gogh felt that his activity must blend with theirs. He became a 'peasant-painter... ploughing on my canvas as they do in their fields' and painting 'with earth'. Through persistent hard work, in his dogged determination to teach himself to draw and paint, he mirrored their effort and toil. Describing his now famous picture of *The Potato Eaters* in 1885, he wrote to Theo: 'I have tried to emphasize that those people, eating their potatoes in the lamplight, have dug the earth with those very hands they put in the dish, and so it speaks of *manual labour*, and how they have honestly earned their food' (Letter 404, April 1885). He painted their skin tones with similar honesty '*the colour of a very dusty potato, unpeeled of course*' (Letter 405, May 1885).

In attempting to make a serious and truthful statement about a figure or about landscape van Gogh was conscious that his rendering of nature often fell so far short of the beauty he perceived in his subjects that it was bound to meet adverse criticism. But if *The Potato Eaters* is a harsh and ugly painting, there can be no doubt about the deep compassion expressed in it. To this extent he had satisfied the critical demand of the nineteenth century for the artist to interpret reality according to his own temperament. He had also met his own aim 'to progress so far that people will say of my work, He feels deeply, he feels tenderly – notwithstanding my so-called roughness, perhaps even because of it.' (Letter 218, July 1882)

The qualification expressed here by van Gogh referred to his uncouth appearance and unsociable behaviour, both of which pained his uncomprehending family. On another occasion he was provoked into a verbal caricature of himself as a big rough barking dog rushing clumsily round the room with wet paws. Beyond the obvious point that a warm heart could beat beneath an ungainly exterior, lay a conviction that an animal-like instinct to let sensations rip on the canvas without 'philosophizing' produced a more telling image. Although van Gogh prided himself on his modernity, this notion linked him, more closely than he might have been

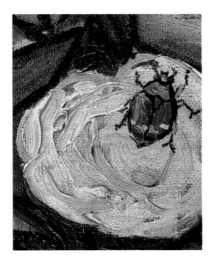

prepared to admit, with a romantic view of a primitive world in which peasants, animals, plants and children thrived in blissful innocence.

We catch a glimpse of his own attempts to preserve a state of artless simplicity when, as a young man of twenty in 1873, he visited London in the employ of the art dealers Goupil & Co. He was entranced by the beauty of the place: 'The country is beautiful here, quite different from Holland or Belgium' (Letter 9, 13 June 1873). 'In all parts of the town there are beautiful parks with a wealth of flowers such as I have never seen anywhere else' (Letter 9a to the Van Stockum-Haanebeek family, 2 July 1873). The freshness of vision could be kept continually alive to new sights, he believed, 'if only one has an open and simple eye'. As in Holland, he took long walks, enjoying the seasonal changes of flower and leaf, and he urged his brother Theo to do likewise.

But it is clear from what he wrote that his innocent eye on the world had already been tutored by art: 'Keep your love of nature, for that is the true way to learn to understand art more and more. Painters understand nature and love her and *teach us to see her*' (Letter 13, January 1874). His vision of landscape was essentially a poetic one, strongly coloured by his reading of John Keats and other Romantic poets, and elevated by a sense of beauty that suffused every experience, whether of life, art or literature. What he encountered in one area recalled its counterpart in another, complementing and reinforcing the sensation. The sky over the Thames brought a painting by Ruysdael or Constable to mind; a picture of Amsterdam by the Dutch artist Thijs Maris reminded him of Heine's lyric, *Meeresstille*. Moments of deep emotion so quickened his response to nature that the death of his landlady's thirteen-year-old daughter prompted a drawing of Streatham Common, sodden with rain. Increasingly, he was drawn to such atmospheric moments of 'still sadness', for nature both inspired and reflected feelings of romantic melancholia in him. The same romantic inclination was apparent in his preference for Gothic features, for the wild and irregular aspects of nature, such as moss growing over roofs, rampant ivy, gnarled and twisted trees. Of all times and seasons, autumn and the half-lit hours of dusk and daybreak were those at which he felt nature to be at her most 'serious and intimate'.

The painting that for him encapsulated these sentiments to perfection was J.-F. Millet's sombre picture *The Angelus*. This scene of a peasant couple praying in the fields at sunset possessed that mysterious and inspired quality which his mentor, the Dutch artist Anton Mauve, referred to as '*it* – that is beauty, that is poetry', van Gogh wrote from London in January 1874 (Letter 13).

As his mood crystallized into one of yearning for a less worldly life, he steeped himself in the teachings of the Bible and began to see things 'with a holier eye'. His social conscience and sympathy for the poor was strengthened by his reading of Dickens and George Eliot and of magazines such the *The Graphic*, the black and white illustrations of which depicted 'intimate modern life as it really is'. But the stirrings that finally persuaded him to renounce art dealing for a life of piety and self-sacrifice brought a shift of focus, rather than a radical change in his aesthetic persuasion. He wrote to Theo that 'a feeling, even a keen one, for the beauties of nature is not the same as a religious feeling, though I think these two stand in close relation to one another'. (Letter 38, 17 September 1875)

Some years later, bent on missionary work, van Gogh travelled to the Borinage, a mining district in southern Belgium, where he was appointed temporarily as an evangelist. There, far from the art world, nature alone offered him inspiration and the blackthorn hedges standing out starkly against the snow seemed to confirm his religious vocation 'like black characters on white paper – like pages of the Gospel' (Letter 127, 26 December 1878). But his excessive zeal in following Christ's example to the letter and his lack of eloquence as a preacher led to his dismissal. The sense of despair and loss of direction that for a time overwhelmed him eventually lifted. In the autumn of 1880 he rechannelled his urge to communicate into drawing, finding his first models in the peasant figures by Millet that he had admired earlier.

It was never van Gogh's intention simply to document. He made careful distinction between his studies, and he made literally hundreds in which he analysed what was in front of him. The final goal, the picture, was to be a distillation of thoughts arising from his subject and endowed with Mauve's 'it'. His robustly matter-of-fact insistence that the artist start from actuality,

7 Letter 477 from Vincent van Gogh to his brother Theo, April 1888,
with a sketch of his painting *Blossoming Pear Tree* (Plate 21), JH1395

from life itself, prevented his work from becoming sentimental: ' The peasant *must b*
that digger *must* dig' (Letter 418, July 1885). In pursuit of the 'startling realism' ach
contemporary illustrators that had absorbed his attention in London, he went on to
idea: 'To draw *a peasant's figure in action*, I repeat, that's what an essentially modern
very core of modern art, which neither the Greeks nor the Renaissance nor the old I
have done.'

Unswerving in his belief that '*people* are more important than anything else' van G
landscape at first took second place to the exacting programme he set himself of st
figure in the hope of making a living by illustration. His only means of support car
brother Theo, who, like him, had followed his uncles into art dealing. Yet despi
generosity, Vincent could never organize his finances to pay for all the peasant r
required. When money ran out he turned to pure nature for refreshment, concentr
landscape settings for his workaday scenes, with reassuring results:
'More and more I feel that drawing the figure is a good thing which indirectly h
influence on drawing landscape. If one draws a willow as if it were a living being
all, it really is – then the surroundings follow in due course if one has concentrat
attention only on that same tree, not giving up until one has put some life in
(Letter 152, October 1881)

Van Gogh worked largely in isolation, and the personification of the natural worl
this passage suggests the close relationship in which he saw himself with nature. F
time he identified it as some opponent to be tamed or from which to wrest a secr
mistress, 'Dame Nature or Reality', to be courted:
'Nature always begins by resisting the artist, but he who really takes it seriously do
that resistance to put him off his stride; on the contrary, it is that much more of a
fight for victory, and at bottom nature and a true artist agree. Nature certainly is '
yet one must seize her, and with a strong hand. And then after one has struggled a
with nature, sometimes she becomes a little more docile and yielding.'
(Letter 152, October 1881)

8 *Vase with Daisies and Anemones*. 1887.
Oil, 61 × 38 cm (24 × 15 in).
State Museum Kröller-Müller, Otterlo, F323 JH1295

little head for abstractions of an acade[...]
[dr]awing and painting, his conscientiousn[...]
[a]ttempt to make a lively rendering of a [...]
[stur]dily those little stems were rooted in the [...]
[becau]se the surface was already so heavily c[...]
[...] the roots and trunks in from the tube, [...]
[th]ey stand there rising from the ground, s[...]
[s]omething, has spoken to me, and that I [...]
[...]e or conventional language derived fro[...]
[rath]er than from nature itself.' (Letter 228, [...]

[...]te instruction he received briefly from M[...]
[Antwe]rp Academy in 1886, van Gogh was enti[...]
[fe]lt, by spontaneous and unconventional [...]
[...] painters but the language of nature whi[...]
[...] ready, nonetheless, to find support for [...]

[...]oners with the brush were artists such a[...]
[pull]ed off a thing from the first stroke and d[...]
[...] Rembrandt created 'hands that lived, b[...]
[...]s' (Letter 427, October 1885). Searchin[...]
[...] paint, van Gogh wrote to Theo that he [...]
[...]which again stimulated him to work wit[...]
[...]eness of touch that produces so much ef[...]
[...] communicates itself to the spectator. F[...]
[...]ring the completeness of his compositio[...]
[...]ut harmoniously from top to bottom, [...]
[f]ragments, without obstinately worryin[...]
[n]early always found it, thanks to his bro[...]
[...] one looks at nature, at a single glance.'

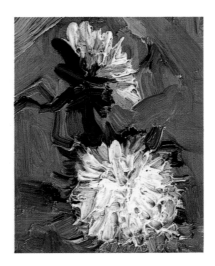

While he was in the Netherlands, van Gogh continually strove to create a three-dimensional palpitating reality, either with brush or pencil. From his scrutiny of painters like Hals, Rubens and others, he saw that colour as well as the vitality of the artist's drawing could be used to express form. But whereas drawing was in the control of artists and could, he felt, be safely left to the guidance of 'that conscience which is called sentiment, their soul', the visual properties of the pigments, were, like the workings of nature itself, something to be learnt. He immersed himself in a study of Delacroix's colour theories, and the buzz of excited thoughts that accompanied his new findings even led him, as he told Theo, to question the springs of creativity:

'The *laws* of the colours are unutterably beautiful, just because they are *not accidental*. In the same way that people nowadays no longer believe in fantastic *miracles*, no longer believe in a God who capriciously and despotically flies from one thing to another, but begin to feel more respect and admiration for and faith in nature – in the same way, and for the same reasons, I think that in art, the old-fashioned idea of innate genius, inspiration, etc., I do not say must be put aside, but thoroughly reconsidered, verified – and greatly modified. However, I do not deny the existence of genius, or even its being innate. But I certainly do deny the inference that theory and instruction should, as a matter of course, always be useless.'

(Letter 371, June 1884)

In fact, his aim in matters of both drawing and colour were identical: to avoid 'realism in the sense of *literal* truth, namely *exact* drawing and local colour' (Letter 402, April 1885). It was not that he saw nature in opposition to his ideas on painting, but that, in the final collaboration, it was up to the artist to orchestrate the masterpiece. 'My great longing is to learn to make those very incorrectnesses, those deviations, remodellings, changes in reality, so that they may become, yes, lies if you like – but truer than the literal truth' (Letter 418, July 1885). As he explained elsewhere: 'I study nature, so as not to do foolish things, to remain reasonable; however, I don't care so much whether my colour is exactly the same, as long as it looks beautiful on my canvas, as beautiful as it looks in nature.'(Letter 429, October 1885)

Van Gogh made a vain attempt to learn the piano in order to understand the connections

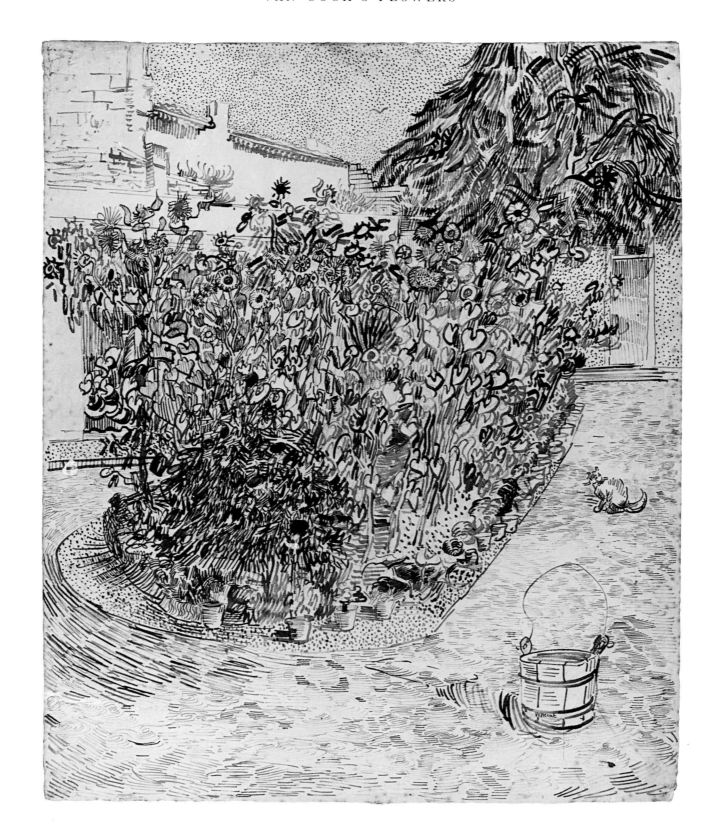

9 *Garden with Sunflowers*. 1888.
Pencil, reed pen and brown ink, 60 × 48.5 cm (23⅝ × 19¼ in).
National Museum Vincent van Gogh, Amsterdam, F1457 JH1539

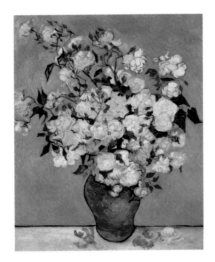

Delacroix drew between the calculated effects of colour harmonies in music and in painting. He spoke rapturously of a splendid 'symphony' of colour, 'simple, and infinitely deep as nature is herself' and he clearly had abstract or symbolic colour values in mind when he considered ways of evoking the sensations aroused by each season:

'Spring is tender, green young corn and pink apple blossoms.

Autumn is the contrast of the yellow leaves with violet tones.

Winter is the snow with the black silhouettes.

But now, if summer is the contrast of blues with an element of orange in the golden bronze of the corn, one could paint a picture which expressed the mood of the seasons in each of the contrasts of the complementary colours (red and green, blue and orange, yellow and violet, white and black).' (Letter 372, July 1884)

The practical application of van Gogh's reflections on colour received its greatest stimulus when he moved to France in 1886, first to Paris and then to Arles. In Paris he came into contact for the first time with the Impressionists and their work, among them Renoir and Monet. His palette, which six months before had been 'thawing', now burst suddenly and brilliantly into bloom in a large number of colourful flower-pieces. It is from this year, 1886, until his death in 1890, a brief but amazingly rich five-year period, that all the paintings in this book are drawn.

In 1888, still in search of colour, van Gogh travelled south as far as Arles in Provence. But instead of the anticipated 'land of the *blue* tones and gay colours', he found sky and countryside white with snow 'like the winter landscapes of the Japanese'. His propensity to link landscape and art was now spurred by the images on Japanese woodblock prints, which he had begun to acquire in Antwerp. When he was given a free run of the store amassed in Paris by the businessman and Orientalist Siegfried Bing, van Gogh's collecting became a passion. Impressed by the calm and simple way of life described in the prints, he imagined that, once in Provence, he had come south to the equivalent of Japan, where people 'live in nature as though they themselves were flowers'. He expected that here his own life would 'become more and more like a Japanese painter's, living close to nature like a petty tradesman' (Letter 540, September 1888).

10 *Vase with Pink Roses*. 1890.
Oil, 93 × 72 cm (36⅝ × 28⅜ in).
From the private collection of Mr and Mrs Walter H. Annenberg, F682 JH1979

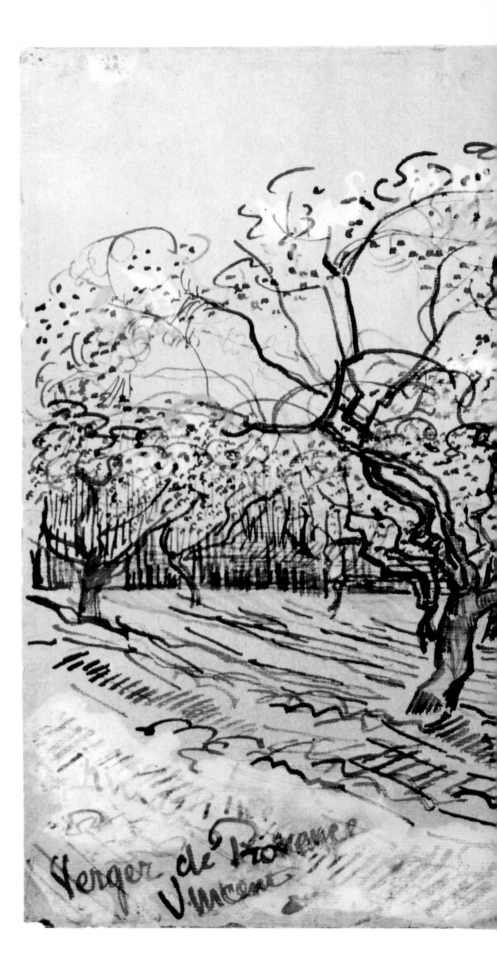

11

ORCHARD WITH BLOSSOMING PLUM TREES

1888. Reed pen heightened with white, 39.5 × 54 cm
(15³/₄ × 21¹/₄in)

National Museum Vincent van Gogh, Amsterdam, F1414 JH1385

'These drawings were made with a reed sharpened
the way you would a goose quill; I intend to make a
series of them, and hope to do better ones than the
first two. It is a method that I had already tried in
Holland some time ago, but I hadn't such good
reeds there as here.' (Letter 478, April 1888)
'Sometimes I regret that I cannot make up my mind
to work more at home and extempory. The
imagination is certainly a faculty which we must
develop, one which alone can lead us to the creation
of a more exalting and consoling nature than the
single brief glance at reality – which in our sight is
ever changing, passing like a flash of lightning – can
let us perceive.... Working directly on the spot all the
time, I try to grasp what is essential in the drawing –
later I fill in the spaces which are bounded by
contours – either expressed or not, but in any case
felt – with tones which are also simplified.'
(Letter B3, to Émile Bernard, April 1888)

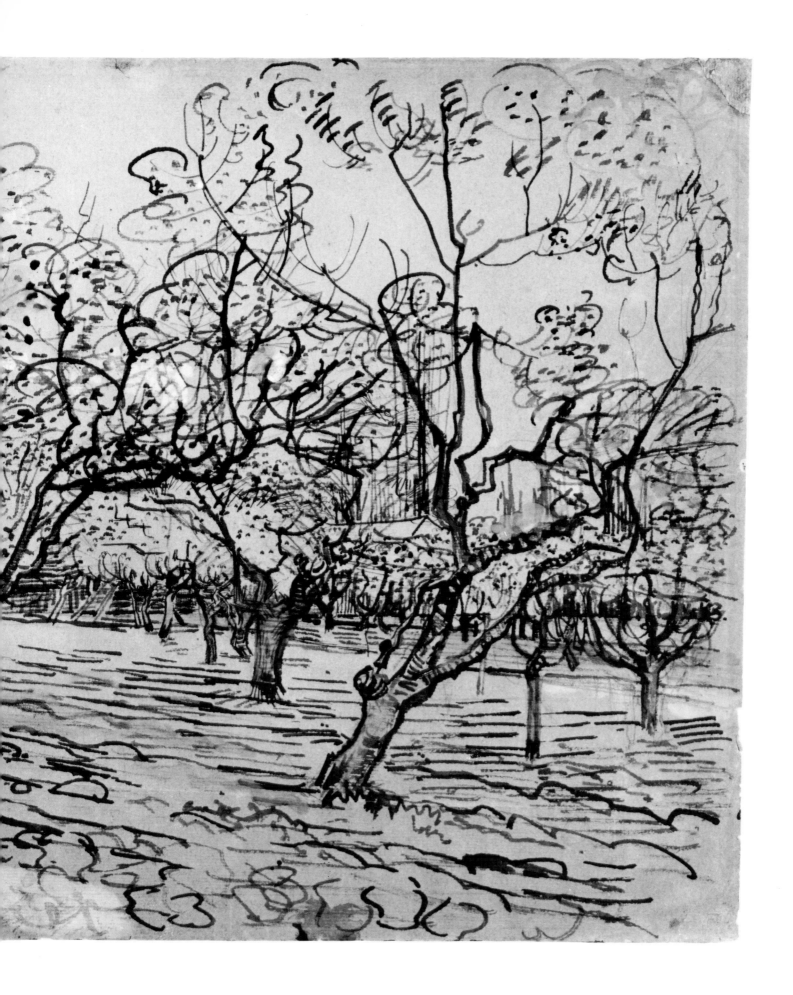

Working full tilt, out of doors whatever the weather, in direct confrontation with the motif, van Gogh sensed a change in himself, which he attributed to the influence of Oriental perceptions: 'One's sight changes: you see things with an eye more Japanese, you feel colour differently. The Japanese draw quickly, very quickly, like a lightning flash, because their nerves are finer, their feeling simpler.' (Letter 500, June 1888)

Van Gogh spent just over a year in Arles, leaving in May 1889 to enter an asylum in Saint-Rémy as a voluntary patient, following the psychological crisis in which he cut off part of his ear. The paintings he made during this period owe their emotional intensity to the fine-tuning of his rapid and, by now, very assured style. With it he gave us a unique interpretation of the character of the south of France: its clarity of light which opened up and drew into focus great dizzying distances and which described the flattened shapes of objects with shadowless brilliance; the relentless sunshine that emblazoned the town and landscape with gold and brought heightened colour juxtapositions into play on his canvas; the intense cobalt blue of the night sky that made the stars appear to him 'more sparklingly gemlike than at home – even in Paris: opals you might call them, emeralds, lapis lazuli, rubies, sapphires' (Letter 499, June 1888); the heat that made a garden of multi-coloured flowers shimmer and vibrate like a Monticelli bouquet (Pl. 35); the landscape itself which suggested one of his most optimistic and resonant images, that of the reaper in the field of wheat: 'it is an image of death as the great book of nature speaks of it,' van Gogh wrote. 'But there's nothing sad in this death, it goes its way in broad daylight with a sun flooding everything with a light of pure gold.' (Letter 604, September 1889)

Referring to the progress he made with his work, van Gogh frequently used the analogy of a seed sown and brought diligently to mature growth. When his life was cut short tragically by his own hand at the age of thirty-seven, he had sold just one painting. To an artist so utterly convinced of what he was about that, as he said, 'I shall try to reach it even at the risk of my own life', his lack of commercial success was a continual disappointment, for which he felt the uncritical speculation of the art market was largely to blame:
'Those high prices one hears about, paid for work of painters who are dead and who were never

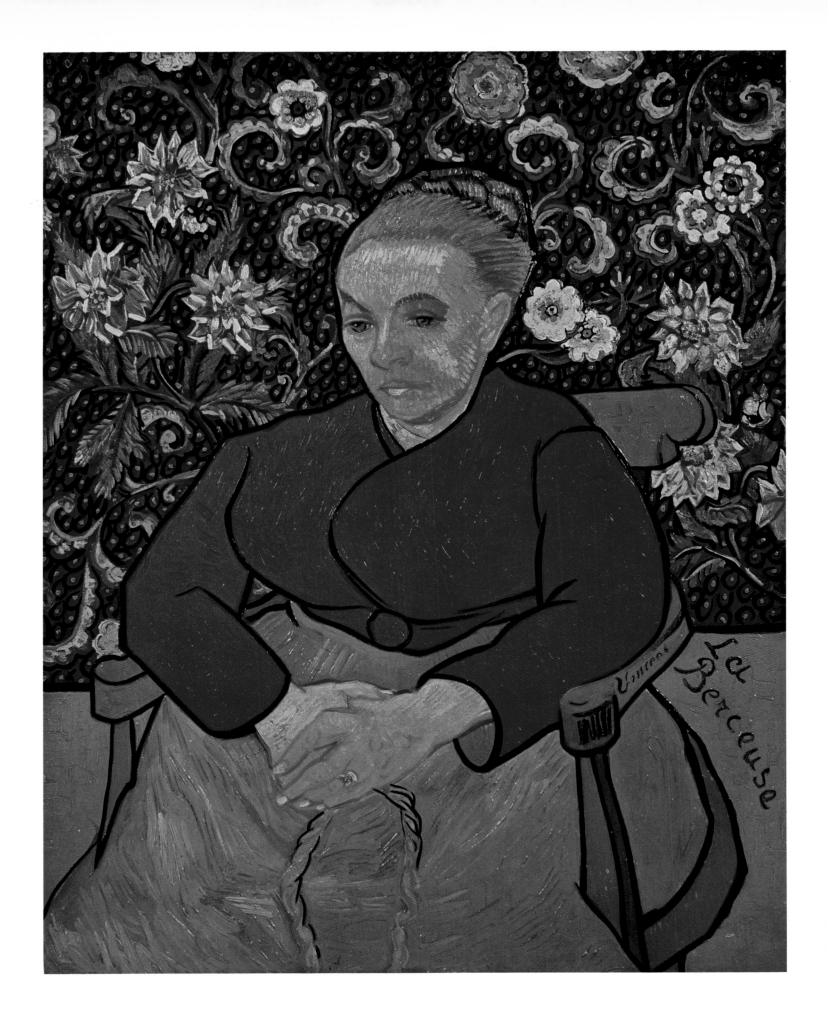

12 *Augustine Roulin (La Berceuse)*. 1889.
Oil, 92 × 73 cm (36¼ × 28¾ in).
State Museum Kröller-Müller, Otterlo, F504 JH1655

paid so much while they were alive, it is a kind of tulip trade, under which the living painters suffer rather than gain any benefit. And it will also disappear like the tulip trade. But one may reason that, though the tulip trade has long been gone and is forgotten, the flower growers have remained and will remain. And thus I consider painting too, thinking that what abides is like a kind of flower growing. And as far as it concerns me, I reckon myself happy to be in it.' (Letter 612, to his mother, October 1889)

A year after van Gogh's death the critic Octave Mirbeau devoted a leading article to him in *L'Echo de Paris*, an avant-garde literary and political journal. It described an artist who might have won Zola's admiration because he painted according to his own eyes and his own disposition: 'Not always literally exact, or rather never exact, for one sees nature through one's own temperament,' as van Gogh himself put it (Letter 399, April 1885). Van Gogh had eyes for nature that lifted him, on occasion, into mystical transports of delight, but he believed that the artist had a duty, in any case, to be fully absorbed by nature in order to apprehend its truth. He read the great book of nature as he had once read the Book itself. And yet, Mirbeau wrote, in attempting to grasp the measure of his achievement, 'he was not absorbed by nature either. He had absorbed nature into himself; he had forced it to unbend, to mould itself into the shapes of his thoughts, to follow him in his flights, even to submit to his highly characteristic deformations.... He spares no effort, to the benefit of the trees, skies, flowers and fields, which he inflates with the astonishing dream of his being.'

THE PLATES

13

PINK PEACH TREES

1888. Oil, 73 × 59.5 cm (28 3/4 × 23 5/8 in)

State Museum Kröller-Müller, Otterlo, F394 JH1379

Van Gogh arrived in the south of France in
February 1888 to find the landscape he had
envisaged as one of bright colour under a strong sun
still wrapped in snow. Despite the bitter weather, he
found Japanese motifs to paint in the winter scene
and in knotty branches of almond just bursting into
bud (*see* Pl. 1). By the end of March a gloriously fine
spell brought the orchards of peach, plum, apple,
pear and apricot into bloom together and van Gogh
was bubbling with excitement: 'I'm up to my ears in
work, for the trees are in blossom and I want to paint
a Provençal orchard of astounding gaiety,' he wrote
to Theo (Letter 473). And he dashed off an
impassioned letter to his friend, the painter Émile
Bernard, as well:
'At the moment I am absorbed in the blooming fruit
trees, pink peach trees, yellow-white pear trees. My
brush stroke has no system at all. I hit the canvas
with irregular touches of the brush, which I leave as
they are. Patches of thickly laid-on colour, spots of
canvas left uncovered, here and there portions that
are left absolutely unfinished, repetitions,
savageries; in short, I am inclined to think that the
result is so disquieting and irritating as to be a
godsend to those people who have fixed
preconceived ideas about technique.... In short, my
dear comrade, in no case an eye-deceiving job.'
(Letter B3)
The painting of these peach trees is certainly not
concerned with 'eye-deceiving', or photographic
realism. Van Gogh has captured his own
exhilaration and the freshness and beauty of spring
in a 'frenzy of impastos', the branches sprouting
tongues in every shade of pink from deep crimson to
palest rose 'against a sky of glorious blue and white'.
He pronounced it 'probably the best landscape I
have done'. When on 30 March he was sent an
obituary of his mentor Anton Mauve (1838-88),
which he thought failed to do Mauve justice, he was
moved to pay personal tribute: 'Something – I don't
know what – took hold of me and brought a lump to
my throat, and I wrote on my picture: SOUVENIR DE
MAUVE – VINCENT THEO' (Letter 472, March 1888).

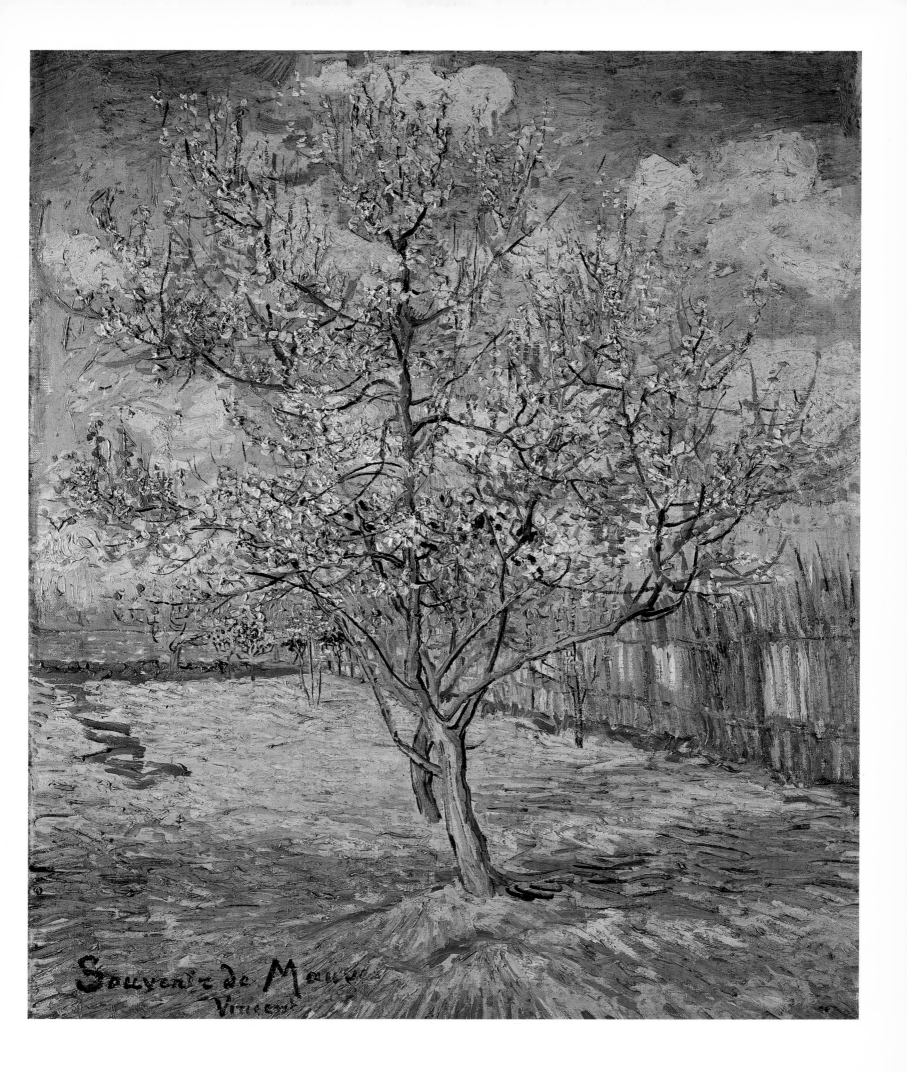

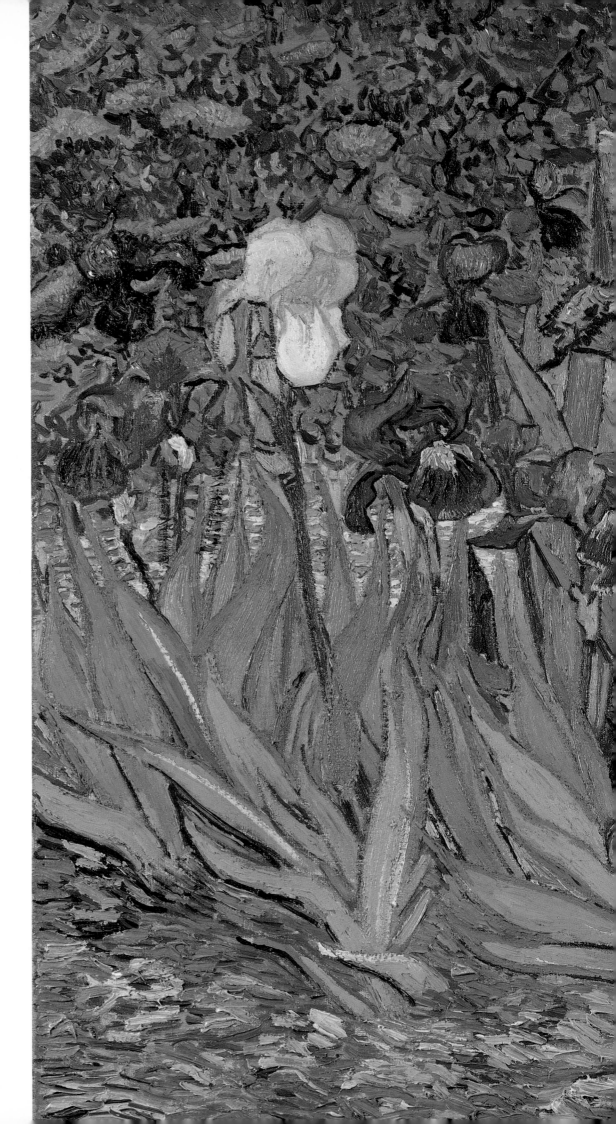

14

IRISES

1889. Oil, 71 × 93 cm (28 × 36 ⅝ in)
Private collection, F608 JH1691

'Romance and romanticism are of our time,
and painters must have imagination and
sentiment. Fortunately realism and
naturalism are not free from it. Zola creates,
but does not hold up a *mirror* to things, he
creates *wonderfully*, but *creates*, *poetizes*, that is
why it is so beautiful.... One starts with a
hopeless struggle to follow nature, and
everything goes wrong; one ends by calmly
creating from one's palette, and nature agrees
with it, and follows. But these two opposites
cannot be separated. The drudging, though it
may seem futile, gives an intimacy with
nature, a sounder knowledge of things. And a
beautiful saying of Doré's (who sometimes is
so clever!) is, *Je me souviens*. Though I believe
that the best pictures are more or less freely
painted by heart, I *can't* help adding that one
can never study nature too much and too
hard. The greatest, most powerful
imaginations have at the same time made
things directly from nature that strike one
dumb.' (Letter 429, October 1885)

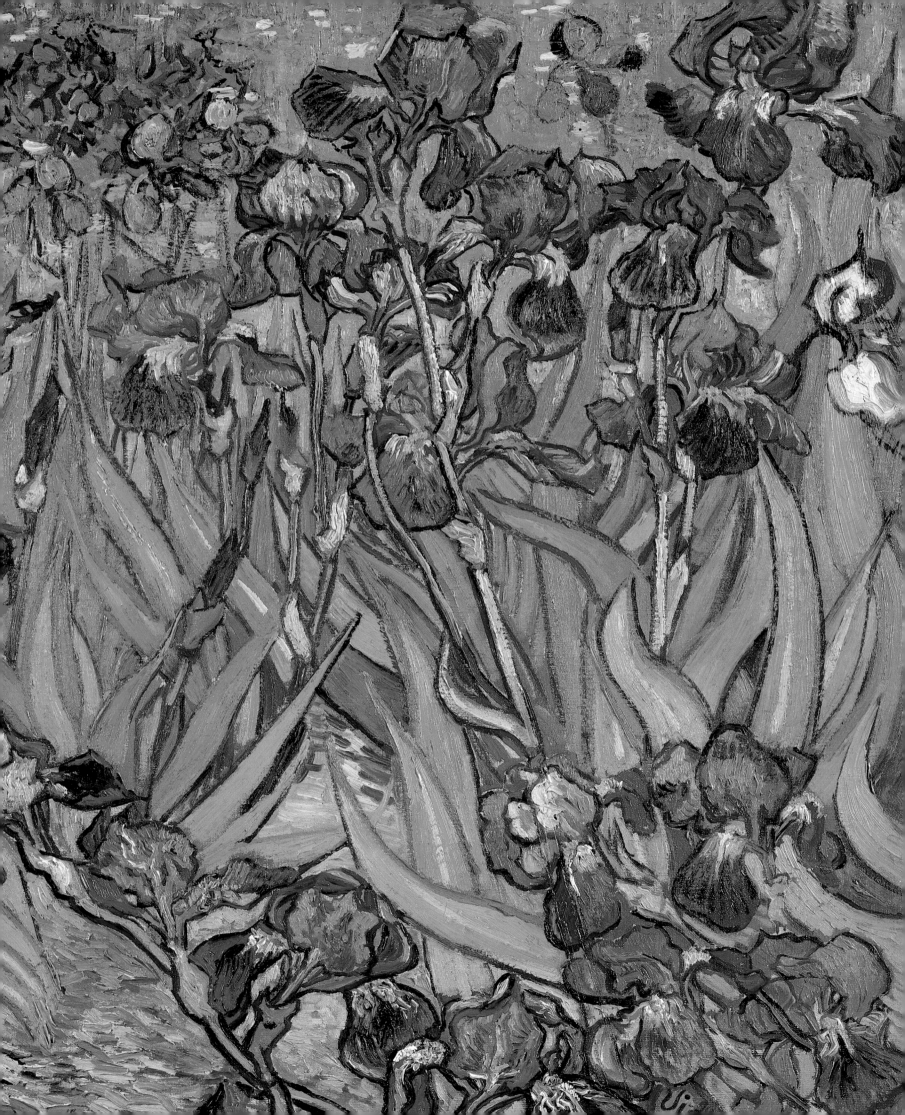

15

BLOSSOMING BRANCHES

1890. Pencil, reed pen, brown ink, 41 × 31 cm (16$^{1}/_{8}$ × 12$^{1}/_{4}$ in)

National Museum Vincent van Gogh, Amsterdam,
F1612 JH2059

16

DEATH'S-HEAD MOTH ON AN ARUM

1889. Oil, 33 × 24 cm (13 × 9$^{1}/_{2}$ in)

National Museum Vincent van Gogh, Amsterdam,
F610 JH1702

Van Gogh's closely observed drawings of insects reflect his devotion to wild life, as well as his familiarity with the teeming pages in Yoshimaro's *A New Book of Insects*. In his painting these creatures enhanced his imaginative colour compositions, like the swarm of 'big blue flies, emerald rose beetles and cicadas' (Letter 614a) encircling the olive orchards, which he saw as a haze of blue continuous with the flowering trees and sky. Butterflies likewise contributed picturesque flashes of contrasting colour and his depiction of what was probably an Emperor, not a Death's-Head Hawk Moth, is unusually graphic in its detail. Catching sight of it in the asylum garden at Saint-Rémy, van Gogh was clearly bewitched by its lavish markings, which he matched with vigorous drawing in the arum plants: 'Yesterday I drew a very big, rather rare night moth, called the death's head, its colouring of amazing distinction, black, grey, cloudy white tinged with carmine or vaguely shading off into olive-green; it is very big. I had to kill it to paint it, and it was a pity, the beastie was so beautiful. I will send you the drawing along with some other drawings of plants.'
(Letter 592, 25 May 1889)
One of these drawings, probably of the same arum patch (*see* endpapers), was done with a reed pen, which van Gogh now handled deftly and inventively. *Blossoming Branches* is typical of his unpretentious rendering of plants and wild flowers placed simply on a white page. It was one of the independent drawings done in the north of France, in Auvers, in the last months of his life, June/July 1890.

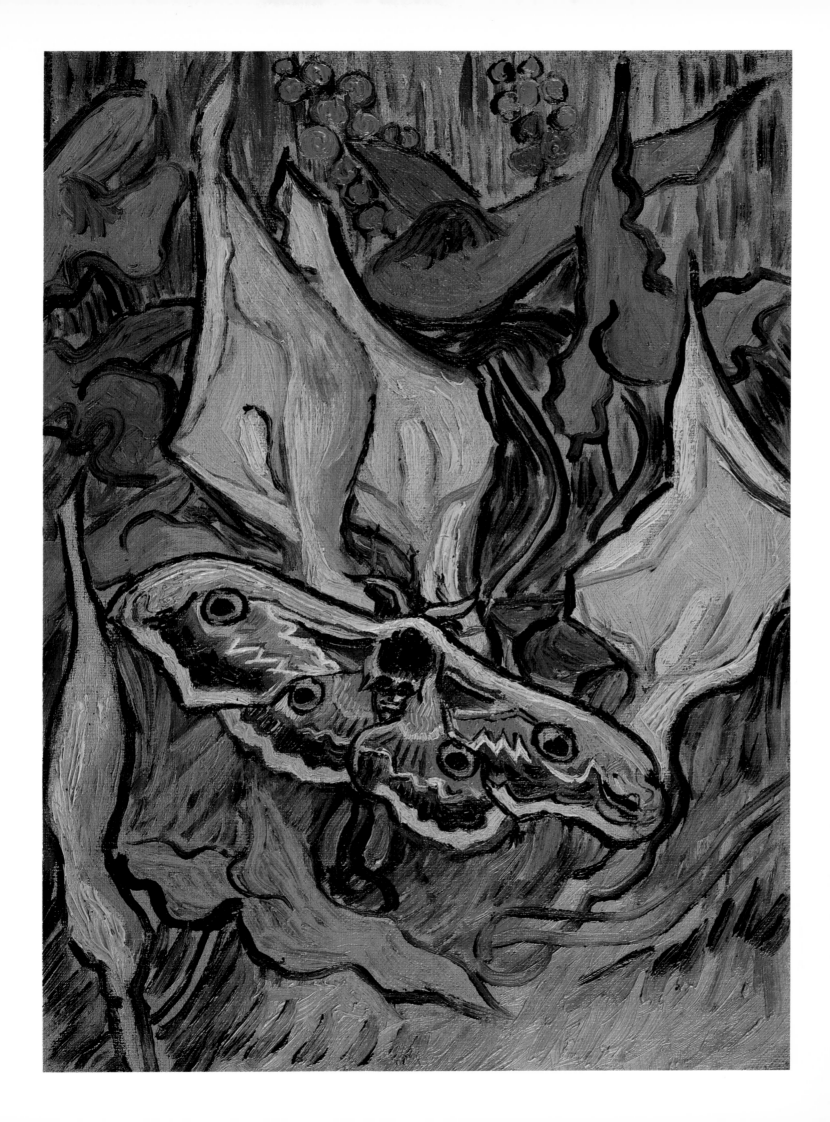

VASE WITH VIOLET IRISES AGAINST A
YELLOW BACKGROUND (detail)

1890. Oil, 92 × 73.5 cm (36¹/₄ × 29¹/₈ in)

National Museum Vincent van Gogh, Amsterdam,
F678 JH1977

During his time in the asylum of Saint-Paul-de-
Mausole in Saint-Rémy van Gogh suffered several
relapses which confined him to the grounds of the
institution, and in a letter to Theo he gave vent to his
feelings of frustration:
'My surroundings here begin to weigh on me more
than I can say – my word, I have been patient for
more than a year – I need air, I feel overwhelmed
with boredom and grief.... I assure you it is
something to resign yourself to living under
surveillance, even supposing it were sympathetic,
and to sacrifice your liberty, keep yourself out of
society, and have nothing but your work without any
distraction.' (Letter 631, May 1890)
Nevertheless, work in itself provided a soothing
distraction. With his mind set on going north to
refresh his flagging spirits, his renewed optimism
and energy burst out in a group of resplendent
flower-pieces, two of roses and two of irises:
'At present all goes well, the whole horrible attack
has disappeared like a thunderstorm and I am
working to give a last stroke of the brush here with a
calm and steady enthusiasm. I am doing a canvas of
roses with a light green background and two
canvases representing big bunches of violet irises,
one lot against a pink background in which the effect
is soft and harmonious because of the combination of
greens, pinks, violets [Pl. 31]. On the other hand,
the other violet bunch (ranging from carmine to
pure Prussian blue) stands out against a startling
citron background, with other yellow tones in the
vase and the stand on which it rests, so it is an effect
of tremendously disparate complementaries, which
strengthen each other by their juxtaposition.' (Letter
633, May 1890)
Violet and yellow offered a radiant and emotive
colour contrast that van Gogh had already relished
in two earlier paintings, in *The Sower* and in a
prospect of Arles from the south with a ditch of irises
in the foreground – 'a little town surrounded by
fields all covered with yellow and purple flowers;
exactly – can't you see it? – like a Japanese dream'
(Letter 487, May 1888).

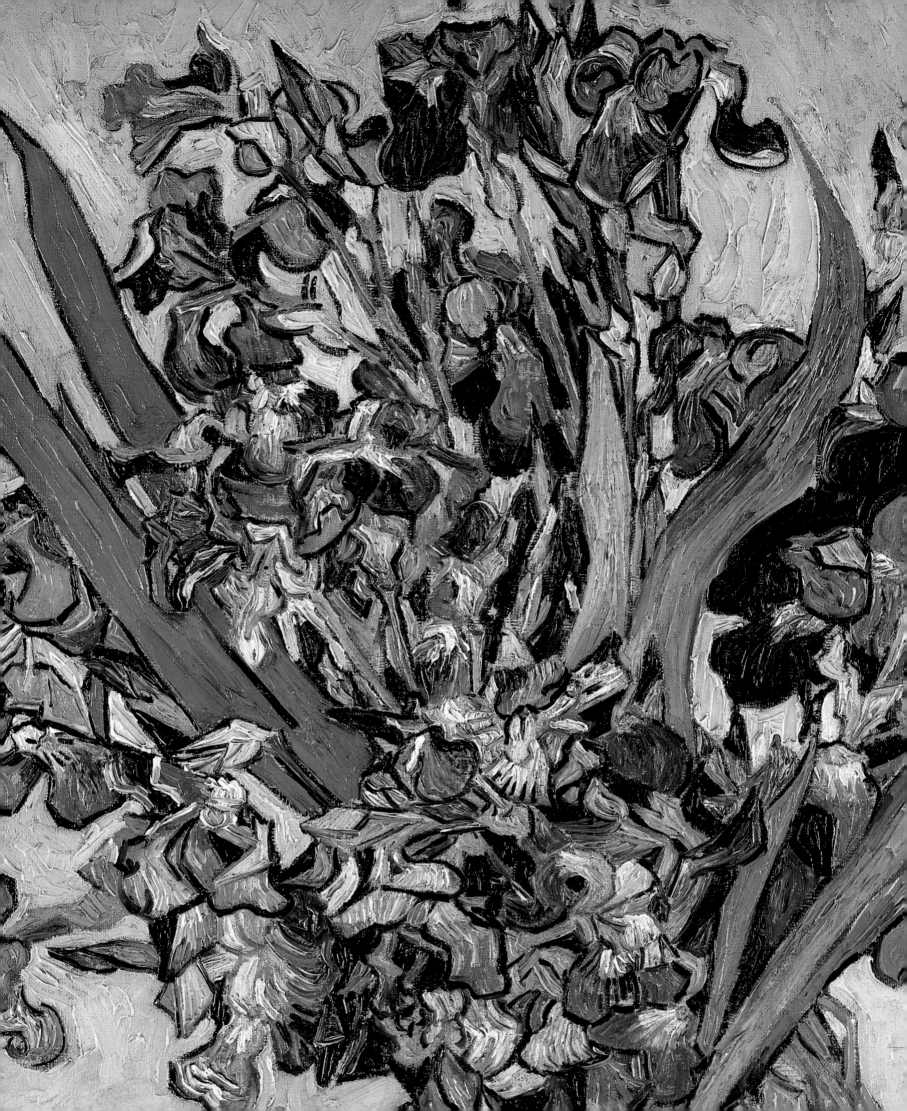

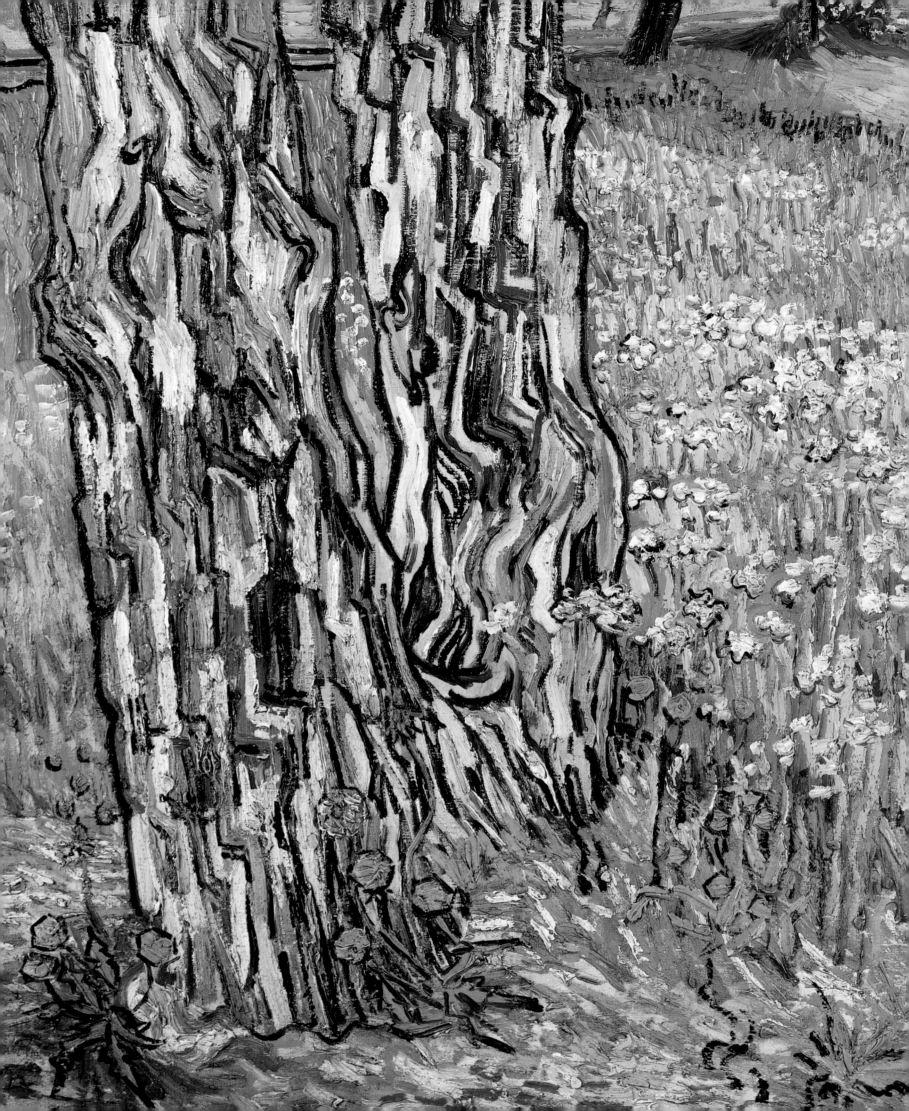

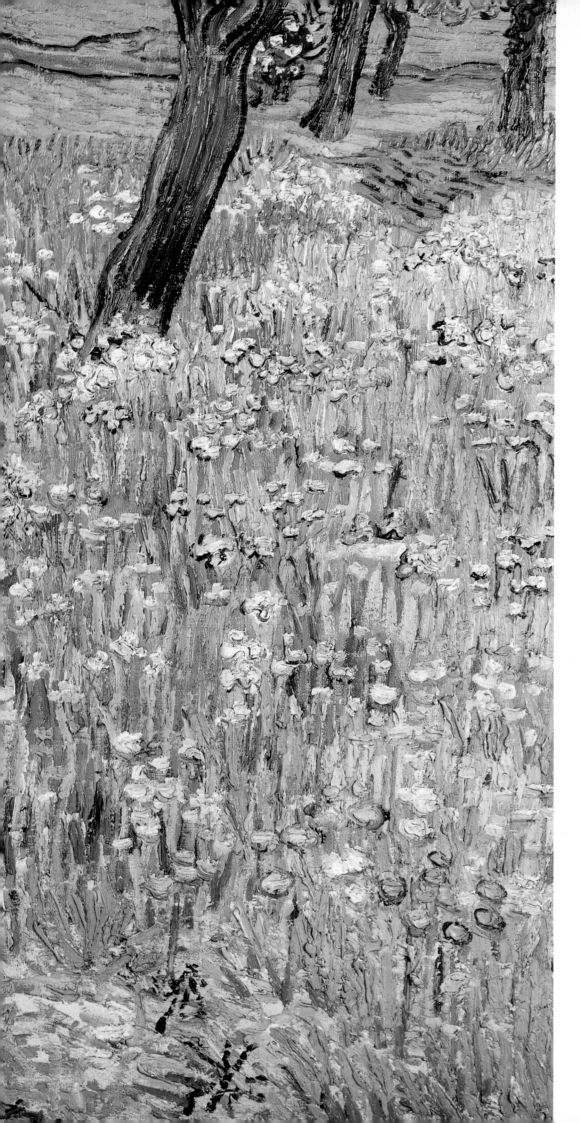

18

FIELD OF GRASS WITH DANDELIONS AND TREE TRUNKS

1890. Oil, 72 × 90 cm (28³/₈ × 35³/₈ in)

State Museum Kröller-Müller, Otterlo, F676 JH1970

Van Gogh's most prolonged bout of illness in Saint-Rémy struck in February during blossom-time, just after he had finished a large outdoor painting of almond branches to celebrate the birth of his nephew Vincent (Pl. 2). 'My work was going well,' he wrote to Theo two months later, 'the last canvas of branches in blossom – you will see that it was perhaps the best, the most patiently worked thing I had done, painted with calm and with a greater firmness of touch. And the next day, down like a brute.' (Letter 628, April 1890) No wonder van Gogh felt out of luck, for on his recovery the blossom had dropped.

Instead he set to work on the spring landscape of the asylum grounds, telling Theo that 'as soon as I got out into the park, I got back all my lucidity for work; I have more ideas in my head than I could ever carry out, but without it clouding my mind. The brush strokes come like clockwork.' (Letter 630, May 1890)

He sketched the view illustrated here, in a letter to Theo: 'I have done two canvases of the fresh grass in the park, one of which is extremely simple, here is a hasty sketch of it. The trunk of a pine violet-pink and then the grass with white flowers and dandelions, a little rose tree and other tree trunks in the background right at the top of the canvas.' (Letter 631, May 1890)

In this beautiful and straightforward treatment of undergrowth flooded with sunlight, the variant rhythms of the landscape seem to come instinctively to van Gogh's brush. The pervasive tranquillity of the scene epitomizes what he experienced as 'the purer nature of a countryside compared with the suburbs and cabarets of Paris' (Letter 595, June 1889).

VASE WITH PEONIES AND ROSES (detail)

1886. Oil, 59 × 71 cm (23$^{1}/_{4}$ × 28 in)

State Museum Kröller Müller, Otterlo, F249 JH1105

Whether he was looking deep into the heart of a
flower through its compact formation of petals, into
a dense entanglement of stems and leaves, at a web
of branches silhouetted against the sky, or at the
idiosyncratic stance of a tree, we encounter van
Gogh listening, intently as always, to the language of
nature as he had first heard it in the Netherlands.
There he had taught himself to translate it
rigorously and with painstaking effort into drawing,
and then to brush life into it with paint. When he
recognized something in his interpretation that
spoke 'straight from my own heart', he sensed that
he had taken an encouraging step forwards.
By the time he reached Paris in 1886, his delight in
Delacroix's theories and in Rubens' handling of
colour had sharpened his own chromatic sensibility,
and he concentrated on expressing his immediate
feeling for nature in terms of colour as well as line.
Characteristically he saw progress towards his new
goal from both a commercial and an artistic
viewpoint, and he wrote hopefully of his chances to
his English painter friend Horace Mann Livens:
'With much energy, with a sincere personal feeling
of colour in nature I would say an artist can get on
here notwithstanding the many obstructions' (Letter
459a, August-October 1886).
Flowers provided him with an obvious source of
colour for his experiments, of which *Vase with Peonies
and Roses* is characteristic of some of his early
harmonies. Richly composed in deep reds and
greens, it still relies on a dark ground to set off a
froth of pink, white and cream petals. Both tone and
compositional arrangement recall the work of
Courbet and of Fantin-Latour, whose *Still Life with
Flowers* of 1877 formed part of the collection made by
the two van Gogh brothers, Vincent and Theo.

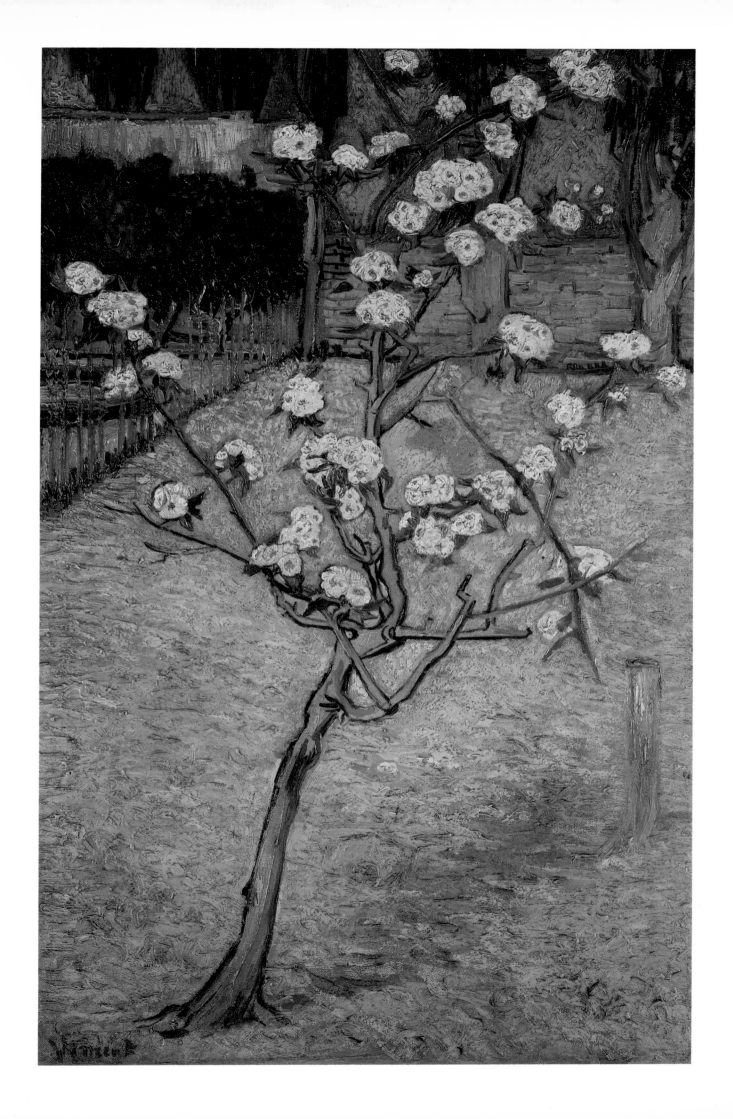

IRISES

1889. Oil on paper mounted on canvas,
62.5 × 48 cm (24³/₄ × 18⁷/₈ in)

National Gallery of Canada, Ottawa, F601 JH1699

'Since I have been here, the deserted garden, planted with large pines beneath which the grass grows tall and unkempt and mixed with various weeds, has sufficed for my work, and I have not yet gone outside,' van Gogh wrote to Theo in late May 1889, soon after his arrival at Saint-Rémy (Letter 592). And he added that 'considering my life is spent mostly in the garden, it is not so unhappy'. Among the many beautiful and arresting subjects he discovered were irises, roses, lilac and one of those hidden corners in the garden 'which represents the eternal nests of greenery for lovers. Some thick tree trunks covered with ivy, the ground also covered with ivy and periwinkle, a stone bench and a bush of pale roses in the cold shadow. In the foreground some plants with white calyxes. It is green, violet and pink.'

Once again flowers provided the material for colour effects, with which van Gogh conjured poetry from the most unassuming of themes, such as this iris plant growing among tufts of rough grass. His concern was to bring 'style' to a portrayal of the simple, humble and everyday and, on this occasion, a patch of untended ground becomes an arena for a vigorous pattern of brushstrokes and harmoniously placed colour contrasts. Yet, the effect remains triumphantly that of the outdoors and is in no way self-conscious. The painting pursued a theme he had already treated once before in Arles and, even more lavishly, in his painting of a large, sprawling clump of violet irises (Pl. 14).

In this last, the areas of colour, with a single white 'rest', are more distinctly divided into violet irises, marigolds, red earth and green 'sword-like leaves', on which, as the critic Félix Fénéon commented, 'the "Irises" violently slash their petals to pieces'. It is more likely that van Gogh was attracted to the flower because of its serenely naturalistic depiction in Japanese popular prints, rather than because it suggested any such dramatic imagery.

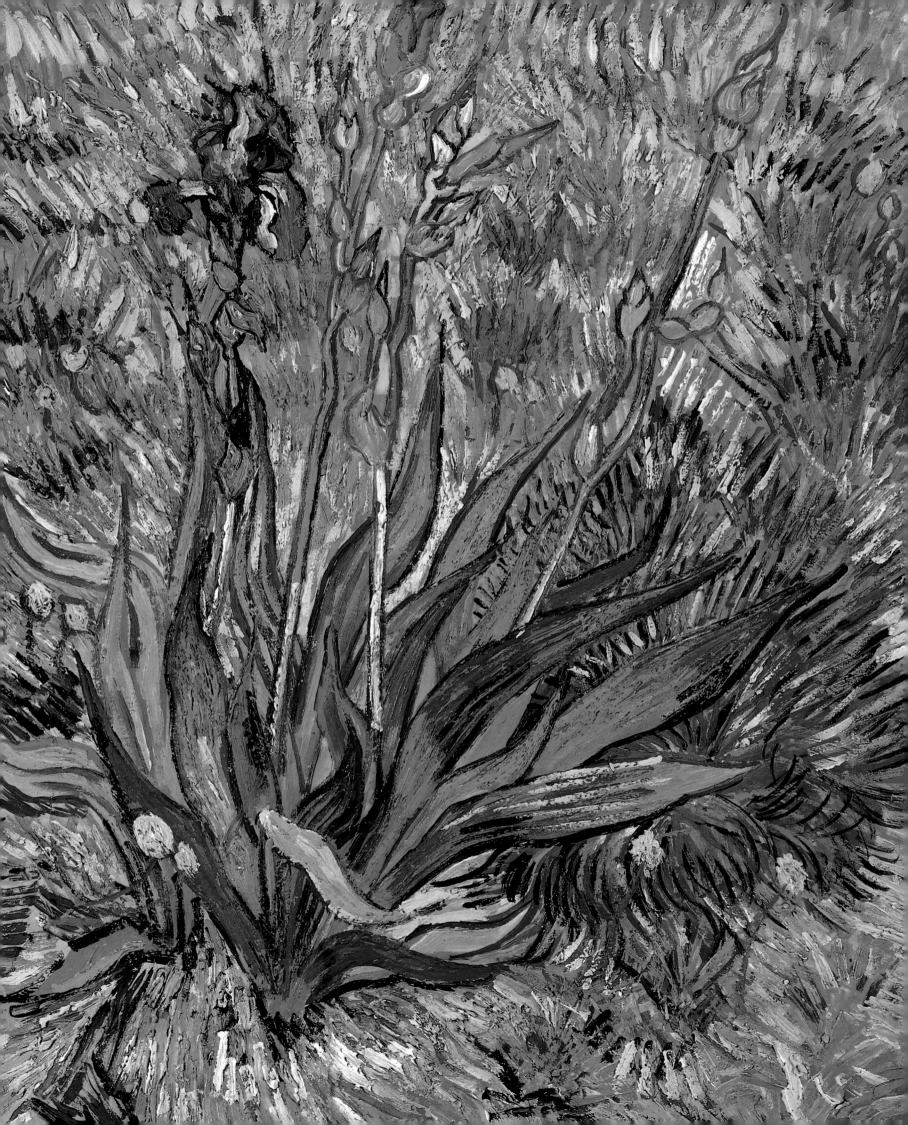

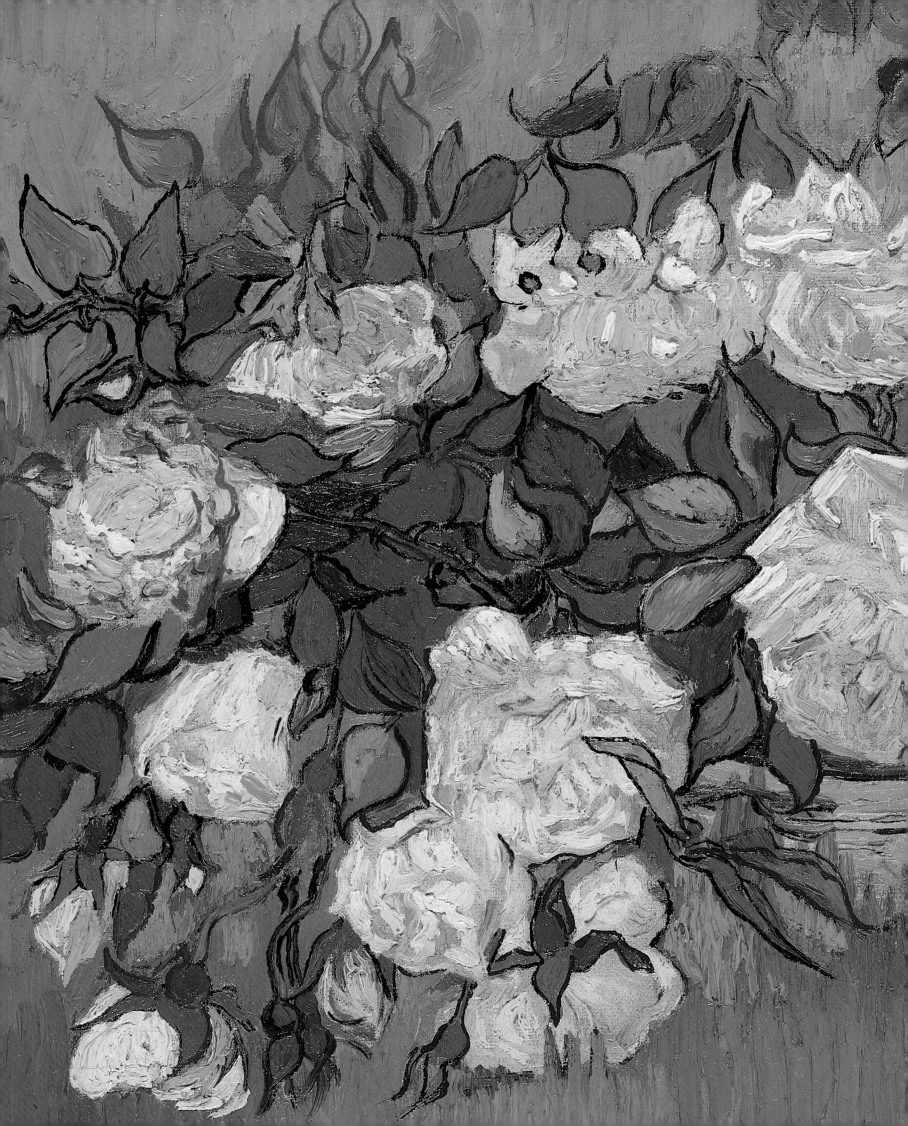

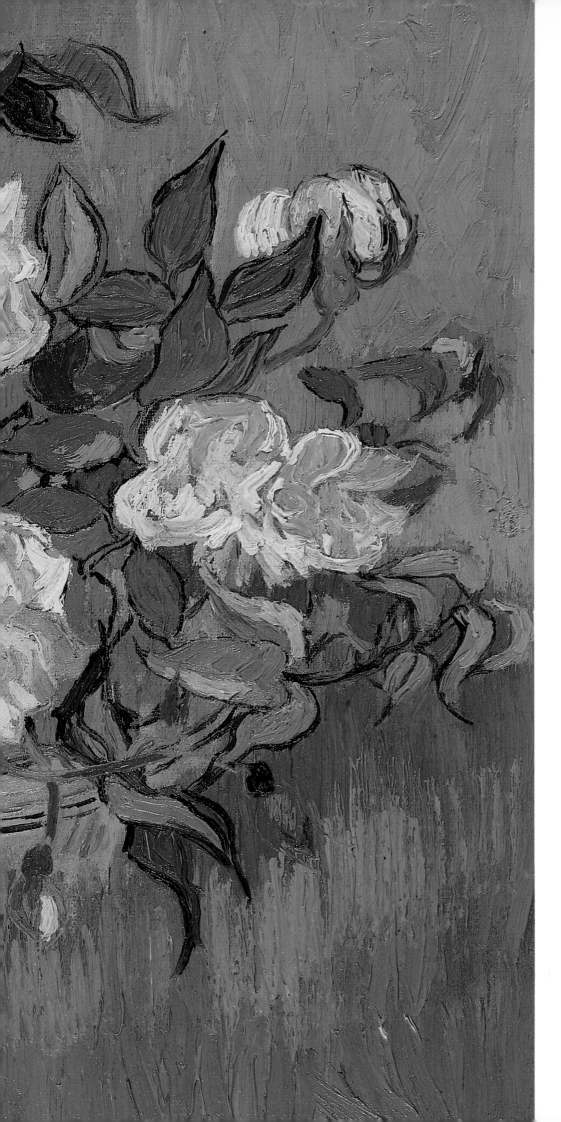

23

PINK ROSES

1890. Oil, 32 × 40.5 cm (12⅜ × 16⅛ in)

Ny Carlsberg Glyptotek, Copenhagen, F595 JH2009

'You will remember that we saw a magnificent garden of roses by Renoir. I was expecting to find subjects like that here.... You would probably have to go to Nice to find Renoir's gardens again. I have seen very few roses here, though there are some, among them the big red roses called Rose de Provence.' (Letter 488, May 1888)

The scarcity of roses van Gogh commented on when he came south to Arles accounts for their surprising absence in his early Provençal canvases. Roses were familiar subject-matter in his contemporaries' work, whereas the irises van Gogh painted were an uncommon choice among European artists. No doubt his enthusiasm for the woodblock prints of Japanese artists such as Hokusai provided the initial inspiration for depicting the iris, although as he told his younger sister, Wil: 'I don't need Japanese pictures here, for I am always telling myself *that here I am in Japan.* Which means that I have only to open my eyes and paint what is right in front of me, if I think it effective' (Letter W7, September 1888). Irises abounded, growing wild in the ditches round Arles.

Van Gogh discovered the theme of roses in the garden of the asylum of Saint-Rémy. The two still lifes he painted while he was a patient there were intended as pendants to vases of irises (Pls. 17, 31). He returned to the theme the following month in Auvers-sur-Oise, just north of Paris, where the lush abundance of wild and garden flowers and the softer northern light inspired the massed arrangement of pink roses illustrated opposite. The green bowl is barely indicated and the roses spill over their container's edge in blowsy profusion. Van Gogh's angled viewpoint suggests that he may have been visualizing the roses as he had seen them growing, possibly in the garden of his physician Dr Gachet, and their natural sprawl makes a telling contrast with the grandly composed still-life portraits (*see* Pl. 10).

BRANCHES OF FLOWERING ACACIA

1890. Oil, 33 × 24 cm (13 × 9^1/$_2$ in)

Nationalmuseum, Stockholm, F821 JH2015

These branches of flowering acacia, or mimosa, with their yellow flowers and silvery leaves were painted in Auvers. Swiftly executed on coarse canvas in a bold diagonal composition, van Gogh uses a welter of impressionist marks to create the character of mimosa, its flowers falling loosely and untidily in long panicles. The broad impasto brushstrokes are almost abstract in effect, combining yellows, lilacs and white against blue-black, with hints of green and touches of pink. In mood it is very reminiscent of the dramatic night skies van Gogh painted in the south of France, in which coloured stars seemed to him to radiate hope from a dark infinity.

The unnaturalistic colour suggests that this picture may even have been painted by evening light, a time which particularly appealed to van Gogh for its intimate atmosphere. On the other hand, the subdued colours may express his wish to return to the muted half-tones and dark/light contrasts of his earlier period in Nuenen, Holland. At that time he was painting a number of still lifes of birds' nests on plain grounds and he explained to Theo that they were 'purposely painted against a black background, because I want it to be obvious in these studies that the objects do not appear in their natural surroundings, but against a conventional background. A *living* nest in nature is quite different – one hardly sees the nest itself, one sees the birds.' (Letter 428, October 1885)

If the branches of flowering acacia were cut rather than painted as they grew, did van Gogh intend to make a similar distinction? Or was he striving for the shimmering effect of silver and gold that had once caught his imagination in the olive orchards in Arles?

JAPANESE VASE WITH ROSES AND ANEMONES

1890. Oil, 51 x 51 cm (20¹/₈ × 20¹/₈ in)

Musée d'Orsay, Paris, F764 JH2045

During the last months of his life in Auvers, van Gogh relied heavily on the friendship and sympathy of the doctor supervising his health, Paul-Ferdinand Gachet, and he confided to Theo: 'Now nothing, absolutely nothing, is keeping us here but Gachet – but he will remain a friend, I should think. I feel that I can do not too bad a picture every time I go to his house, and he will continue to ask me to dinner every Sunday or Monday' (Letter 638, June 1890). Although van Gogh complained about the size of the meals, he clearly derived pleasure from the company of this informed, if eccentric art lover, owner of 'a *very* fine Pissarro' and 'two fine flower pieces by Cézanne'. He reported that Gachet's house was 'full of black antiques, black, black, black, except for the impressionist pictures mentioned' (Letter 635, May 1890). The atmosphere clearly weighed on him for he repeated that it was 'full, full like an antique dealer's, of things that are not always interesting. But nevertheless there is this advantage, there is always something for arranging flowers in or for a still life'. (Letter 638)

In return for the doctor's kindness, van Gogh painted his portrait and that of his daughter, as well as his house and garden, and he also made a number of paintings of flowers, including several still lifes in vases. One of the admired Cézannes may have suggested the rounded table edges, complementing bulbous vases and simplified, schematic flower forms, to be seen in several flower-pieces at this time.

By contrast, the bright colours in the painting illustrated here evoke the light-hearted Oriental mood he was always in quest of and symbolized here by the knotted branch on the Japanese vase. The composition, with its assertively angled table top and curiously jutting rose stem, clearly takes its cue from the shape of the vase, while the painting of the flowers invokes the decorative stylized shapes pictured in Japanese prints.

TWELVE SUNFLOWERS IN A VASE

1888. Oil, 91 × 71 cm (35^7/$_8$ × 28 in)

Neue Pinakothek, Munich, F456 JH1561

'You know that the peony is Jeannin's, the hollyhock belongs to Quost, but the sunflower is mine in a way,' van Gogh told Theo (Letter 573, January 1889), and for many people his name is associated uniquely with this flower.

His first drawings and paintings of sunflowers were made in 1887 in Paris where he saw them growing naturally in the cottage gardens around Montmartre. At the end of the season, as their heads faded and petals crumpled into flames around the ripening seed discs, he discovered one of his most fanciful still-life themes and one that evidently excited Gauguin's admiration. Starting from a simple harmony based on blue and yellow in *Two Cut Sunflowers, One Upside Down* (Pl. 28), he explored next the effect of a red ground and, in the last of a trio, *Four Cut Sunflowers, One Upside Down* (Pl. 4), he expanded the composition, enriching the orchestration of his palette with a flurry of flickering brushwork.

In Arles he returned to a more familiar interpretation, drawing a large bed of sunflowers 'in a little garden of a bathing establishment' (Pl. 9). Gradually the idea of the flower with its symbolic name and colour took hold of his imagination and came to represent all his hopes for a meaningful new life in the south, together with Gauguin and a flourishing studio of artists. In August 1888 he wrote to his friend Émile Bernard:

'I am thinking of decorating my studio with half a dozen pictures of "Sunflowers", a decoration in which the raw or broken chrome yellows will blaze forth on various backgrounds – blue, from the palest malachite green to *royal blue*, framed in thin strips of wood painted with orange lead.

Effects like those of stained-glass windows in a Gothic church.' (Letter B15)

A few days later a letter to Theo related:
'I am hard at it, painting with the enthusiasm of a Marseillais eating bouillabaisse.... I have three canvases going – 1st, three huge flowers in a green vase, with a light background, a size 15 canvas; 2nd, three flowers, one gone to seed, having lost its petals, and one a bud against a royal-blue background, size 25 canvas; 3rd, twelve flowers and buds in a yellow vase (size 30 canvas) [Pl. 27]. The last one is therefore light on light, and I hope it will be the best.

Probably I shall not stop at that.' (Letter 526)

Indeed van Gogh was so pleased with these flower-pieces that he charged himself up to repeat the achievement the following year by making copies of them: 'Now to get up heat enough to melt that gold, those flower tones, it isn't everybody who can do it, it needs the whole and entire force and concentration of a single individual.' (Letter 573, January 1889)

Vase with Fourteen Sunflowers (Pl. 29) was one of these so-called replicas, but it was not identical to its original, now in the National Gallery in London (Pl. 6). The detail illustrated focuses on the manner in which van Gogh enlivened the flower centres with blue and red accents.

His extraordinary sense of colour correspondencies was central to his vision of natural harmony and it gave him the striking idea of hanging these glowing sunflowers, like 'candelabra' or the outer wings of a triptych, on either side of his portraits of *Augustine Roulin (La Berceuse)* (Pl. 12). 'And then the yellow and orange tones of the head will gain in brilliance by the proximity of the yellow wings.' (Letter 592, May 1889)

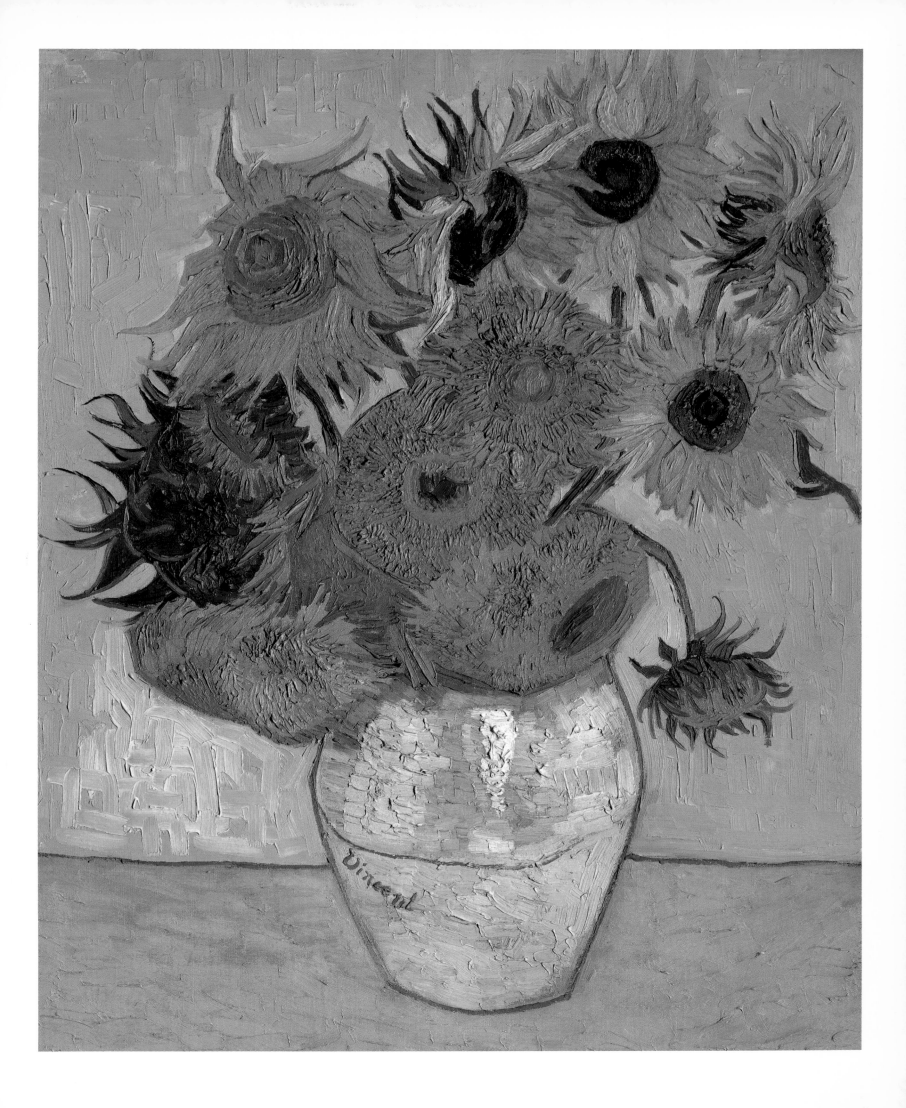

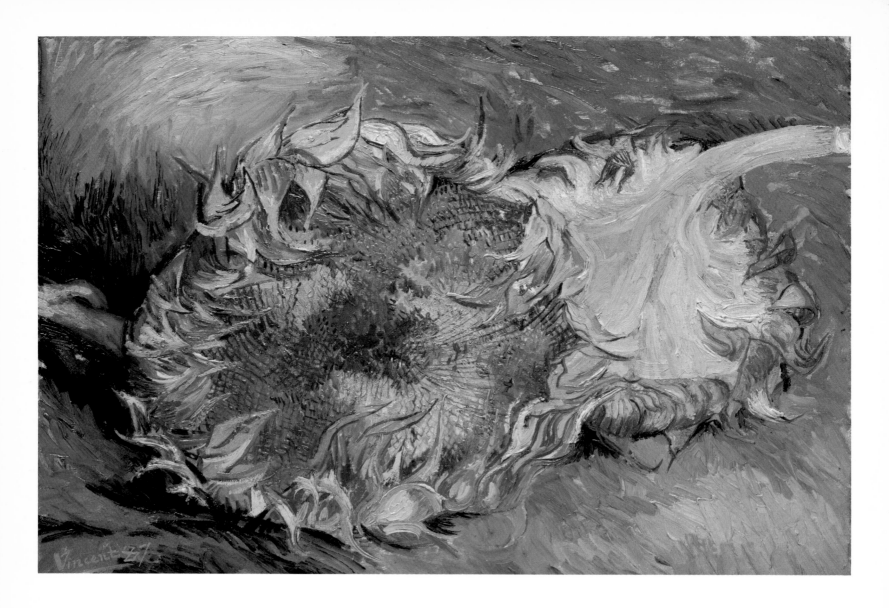

28

TWO CUT SUNFLOWERS, ONE UPSIDE DOWN

1887. Oil, 43 × 61 cm (16^{7}/$_{8}$ × 24 in)

Metropolitan Museum of Art, New York, F375 JH1329

29

VASE WITH FOURTEEN SUNFLOWERS (detail)

1889. Oil, 95 × 73 cm (37^{3}/$_{8}$ × 28^{3}/$_{4}$ in)

National Museum Vincent van Gogh, Amsterdam,
F458 JH1667

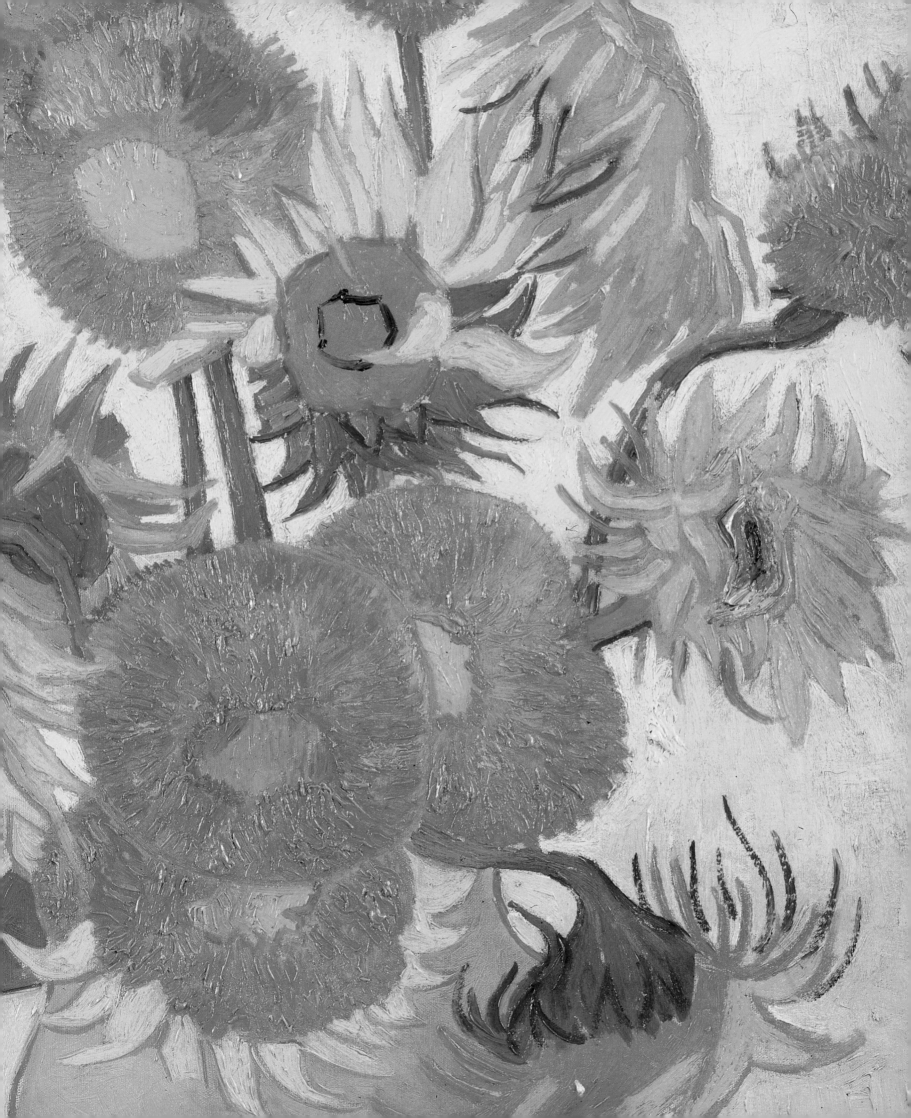

30
VASE WITH POPPIES

1886. Oil, 56 × 46.5 cm (22 × 18¹/₂ in)

Wadsworth Atheneum, Hartford, Connecticut,
F279 JH1104

Van Gogh arrived in Paris towards the end of
February 1886. Living there was more costly than in
Antwerp and he was hard up. Nevertheless, that
summer he wrote in English to his friend H.M.
Livens that there were, in theory at least, more
opportunities to sell paintings in Paris and to
exchange pictures with fellow artists: 'With much
energy, with a sincere personal feeling of colour in
nature I would say an artist can get on here
notwithstanding the many obstructions. And I
intend remaining here still longer.' And he went on
to describe what he had been doing:
'I have lacked money for paying models else I had
entirely given myself to figure painting. But I have
made a series of color studies in painting, simply
flowers, red poppies, blue corn flowers and myosotys
[sic], white and rose roses, yellow
chrysanthemums – seeking oppositions of blue with
orange, red and green, yellow and violet seeking *les
tons rompus et neutres* to harmonise brutal extremes.
Trying to render intense colour and not a grey
harmony.
Now after these gymnastics I lately did two heads
which I dare say are better in light and colour than
those I did before.
So as we said at the time: in *colour* seeking *life* the
true drawing is modelling with colour.
I did a dozen landscapes too, frankly *green*
frankly *blue*.
And so I am struggling for life and progress in art.'
(Letter 459a, August to October 1887)
Van Gogh painted his first and most extensive group
of flower paintings during his stay in Paris in 1886
and 1887. The flower-piece illustrated and *Vase with
Poppies, Daisies, Cornflowers and Peonies* (Pl. 36), in
which red poppies are also the dominant element,
must have been two of his earliest colour exercises.

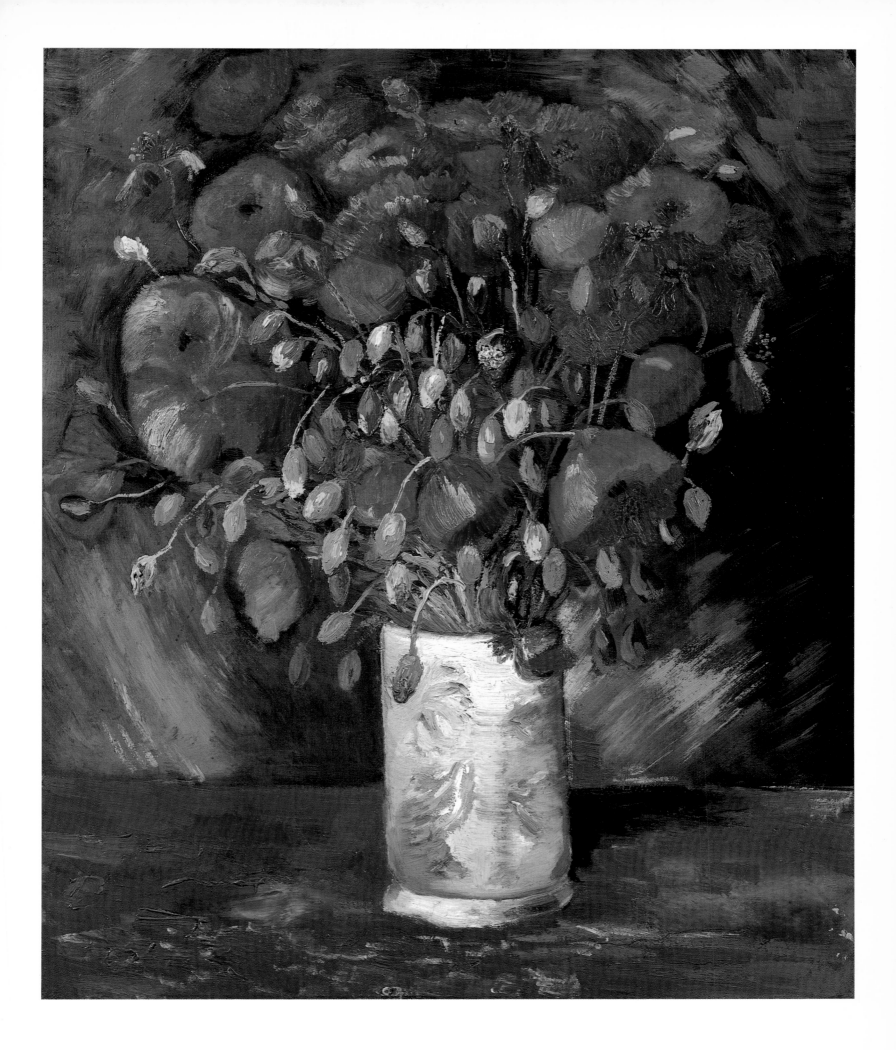

31
VASE WITH VIOLET IRISES AGAINST A PINK BACKGROUND

1890. Oil, 73 × 93 cm (28³/₄ × 36³/₈ in)

Metropolitan Museum of Art, New York, F680 JH1978

During the final days of his stay in the asylum of
Saint-Rémy van Gogh was working 'like a man in a
frenzy' on bunches of flowers. He wrote to the critic
J.J. Isaäcson that 'these flowers are an avalanche of
roses against a green background, and a very big
bouquet of irises, violet against a yellow
background, against a pink background' (Letter
614a, May 1890). Unfortunately the pink in the
background of the bunch illustrated has sunk, thus
depriving the painting of some of the warmth and
gaiety of van Gogh's original conception, but its
natural eloquence remains undiminished.
Van Gogh explained his creative deliberation as the
act of listening to nature speak and a simultaneous,
unrelenting effort to grasp its essential message with
pencil or brush. 'It is the painter's duty to be entirely
absorbed by nature and to use all his intelligence to
express sentiment in his work so that it becomes
intelligible to other people,' he wrote to Theo during
his early struggles as an artist (Letter 221, July
1882). In the process he became one of nature's most
ardent disciples and most passionate preachers. He
interpreted it in a clear, down-to-earth manner,
emulating those he felt to be completely in tune with
nature – Zola, Cézanne, Millet and, of course, the
Japanese. 'Millet is the voice of the wheat, and Jules
Breton too,' he wrote in the same letter to Isaäcson.
For his part, van Gogh gave powerful and
unparalleled expression to the sunflower and, from
the equally joyful attention he paid to the iris, its
colour complementing that of the sunflower, it can
be said that his was the first Western voice to
sing of the iris.

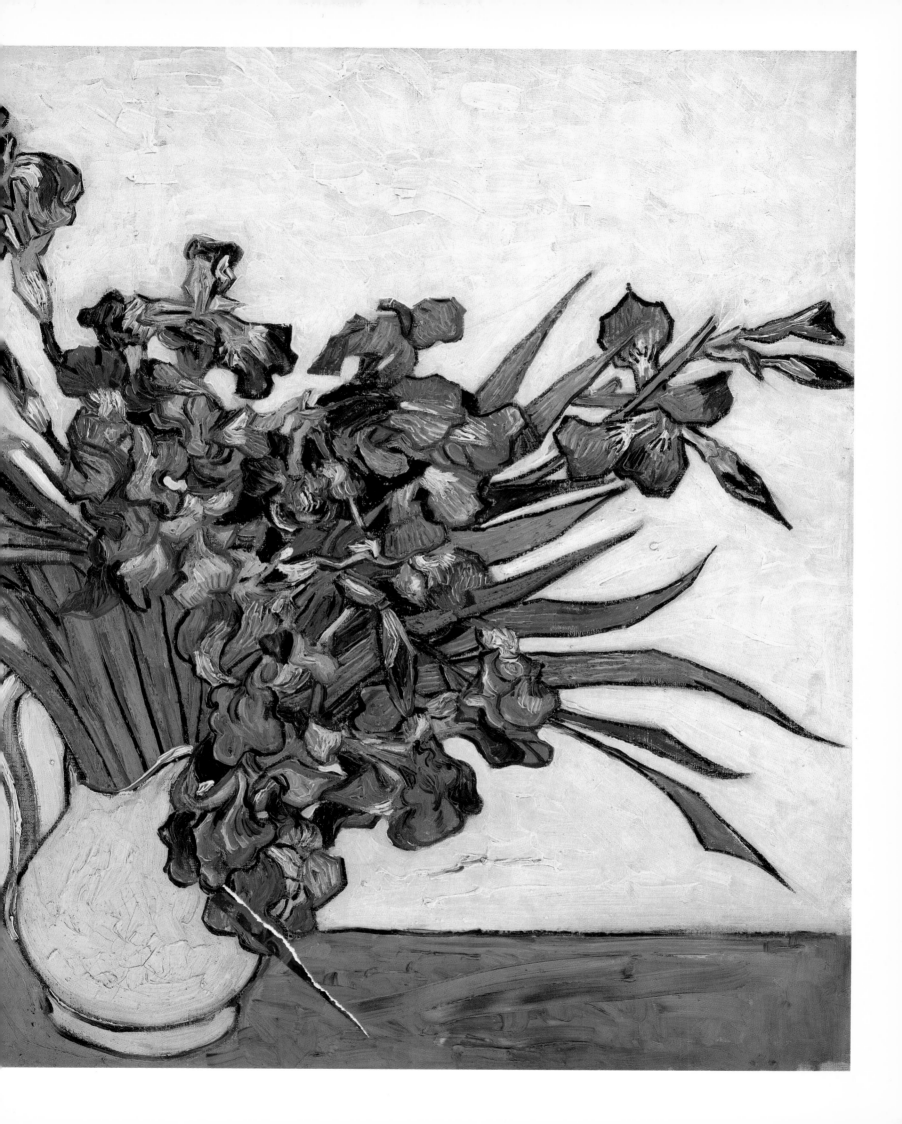

WILD ROSES WITH A BEETLE

1890. Oil, 32.5 × 23.5 cm (13 × 9¹/₂ in)

National Museum Vincent van Gogh, Amsterdam,
F749 JH2012

'Auvers is very beautiful, among other things a lot of
old thatched roofs, which are getting rare...really it
is profoundly beautiful, it is the real country,
characteristic and picturesque, ' van Gogh wrote to
Theo and his wife Jo on arrival in Auvers (Letter
635, May 1890). He was thankful to have left the
city. 'Here one is far enough from Paris for it to be
the real country, but nevertheless how changed it is
since Daubigny. But not changed in an unpleasant
way, there are many cottages and various modern
middle-class dwellings very radiant and sunny and
covered with flowers.'(Letter 637, May 1890)
As he settled down to work and recovered his
serenity in the countryside he felt that it had done
him good to go south, 'the better to see the North'.
One of the sights he enjoyed in the North was the
extravagant growth of roses with which he promptly
filled several canvases. In the painting illustrated, he
celebrates light, fresh air, luxuriant wildness and
what the French writer Pierre Loti described as
'some free-and-easy beetle'. Loti's Japanese fantasy,
Madame Chrysanthème, seems to have fascinated van
Gogh and infused his romantic notion of life lived
close to nature. Intrigued by small details of wildlife,
he deeply respected the seriousness of artists like
Karl Bodmer who devoted their lives to discovering
the poetry hidden in nature's meanest manifestation.
'I admire and love the man who knew the whole
forest of Fontainebleau, from the insect to the wild
boar and from the stag to the lark, from the great oak
and the rock mass to the fern and the blade of grass.
Now a thing like that is not felt, nor even found by
any chance comer.' (Letter 602, August 1889)

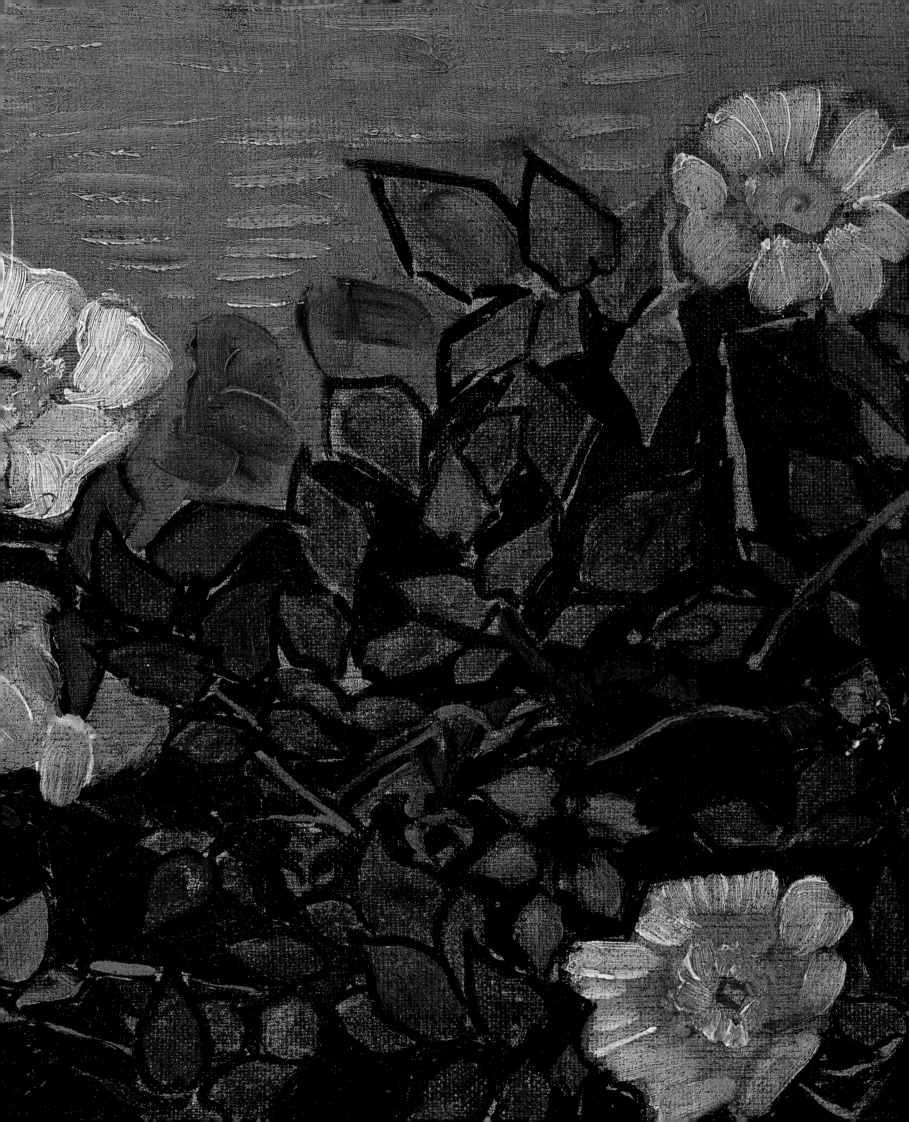

34

VASE WITH GLADIOLI

1886. Oil on canvas, 48.5 × 40 cm (19$^{1}/_{4}$ × 15$^{3}/_{4}$ in)

National Museum Vincent van Gogh, F248a JH1148

While living in Nuenen in the south of Holland, from the end of 1883 to 1885, van Gogh had already studied the example of those 'colourists among colourists' – Frans Hals, Veronese, Rubens and Velázquez. Eugène Delacroix drew his special admiration and his theories on colour contrasts were of paramount importance to van Gogh's development: 'He makes us feel the life of things, and the expression, and the movement, that he *absolutely dominates his colours*' (Letter 439, December 1885). From now on colour was to dominate van Gogh's own thinking and the emotional impact of his painting: 'What colour is in a picture, enthusiasm is in life,' he wrote to Theo (Letter 443, January 1886).

Before he arrived in Paris van Gogh was only dimly aware of the colour experiments going on there: '*There is a school – I believe – of impressionists. But I know very little about it*' (Letter 402, April 1885). Once in the capital he quickly became familiar with the work of Monet, Sisley, Renoir and Degas, who showed their paintings on the Grand Boulevard, and, sympathizing with their natural and unconventional vision, he began seriously to apply his own colour theories using flowers as models. Gladioli featured in several arrangements in which he explored harmonies based on red, blue and yellow. The flowers in *Vase with Gladioli* were modelled entirely in colour using bold impasto strokes and dabs suggestive of gladioli florets. As shapes to paint, he clearly found the gladioli spikes rather stiff, for he usually disturbed their formality with wiry-stalked asters or bent stems, dangling over the side of the vase and lying on the table.

35
GARDEN WITH FLOWERS

1888. Oil, 72 × 91 cm (28³/₈ × 35⁷/₈ in)

Gemeentemuseum, The Hague (on loan from the
Netherlands Office for Fine Art), F429 JH1513

'Under the blue sky the orange, yellow, red
splashes of the flowers take on an amazing
brilliance, and in the limpid air there is a
something or other happier, more lovely than
in the North. It vibrates like the bouquet by
Monticelli which you have. I reproach myself
for not painting flowers here.... Oh, these
farm gardens, with their lovely big red
Provençal roses, and the vines and the fig
trees! It is all a poem, and the eternal bright
sunshine too, in spite of which the foliage
remains very green.' (Letter 519,
August 1888)

Van Gogh's joy in the sensations of summer
in Provence inspired several painted studies
and drawings of gardens, including that of a
bathing establishment (Pl. 9). In a letter to
his younger sister Wil the previous month he
described the scintillating effect of the garden
illustrated here:

'I have a study of a garden one metre wide,
poppies and other red flowers surrounded by
green in the foreground, and a square of blue
blowballs. Then a bed of orange and yellow
Africans, then white and yellow flowers, and
at last, in the background, pink and lilac, and
also dark violet scabiosas, and red
geraniums, and sunflowers, and a fig tree and
an oleander and a vine. And in the far
distance black cypresses against low white
houses with orange roofs — and a delicate
green-blue streak of sky.

Oh, I know very well that not a single flower
is drawn completely, that they are mere dabs
of colour, red, yellow, orange, green, blue,
violet, but the impression of all these colours
in their juxtaposition is there all right, in the
painting as in nature. But I suppose you
would be disappointed, and think it
unbeautiful, if you saw it. But you see that
the subject is rather summery.' (Letter W5)

36

VASE WITH POPPIES, DAISIES, CORNFLOWERS AND PEONIES

1886. Oil, 99 × 79 cm (39 × 31¹/₈ in)

State Museum Kröller-Müller, Otterlo, F278 JH1103

The exuberant colour in this profusion of field and garden flowers, stuffed into the vase and tumbling over the table, marks a complete change from the dark canvases van Gogh was painting in Antwerp and even from the low-keyed *Vase with Hollyhocks* (Pl. 3) painted in the same year. He was still experimenting with his palette, avoiding a slavish imitation of local colour and instead enjoying the freedom of colours 'which form a whole and harmonize, which stand out the more in contrast to another colour scheme' (Letter 429, October 1885). Van Gogh was clearly after effect.

The influence of the French Impressionists was beginning to make itself felt, although van Gogh admitted to H.M. Livens that 'since I saw the impressionists I assure you that neither your colour nor mine as it is developping [sic] itself, is *exactly* the same as their theories' (Letter 459a, August-October 1887). Apart from complementary oppositions, van Gogh still seems to be interested in the dark/light effects that he discovered while painting his sober pictures of peasants, whose skin tones could be made 'to stand out like lights' from their dingy surroundings. The image of lights is particularly apt when applied to the group of star-like daisies whose placement enhances the radiant effect he was after.

Van Gogh's hollyhocks were almost certainly inspired by the cottage garden pictures of Ernest Quost, a painter of 'magnificent and perfect hollyhocks' whom van Gogh deferred to as 'Père Quost', although he was only nine years older than van Gogh. Quost had first studied plants for his job as a decorator at Sèvres Porcelain Manufactory, and his close knowledge of them is evident in his paintings of flowers growing naturally in country gardens. His colours are light and fresh and van Gogh clearly considered him as much a colourist as the Impressionists.

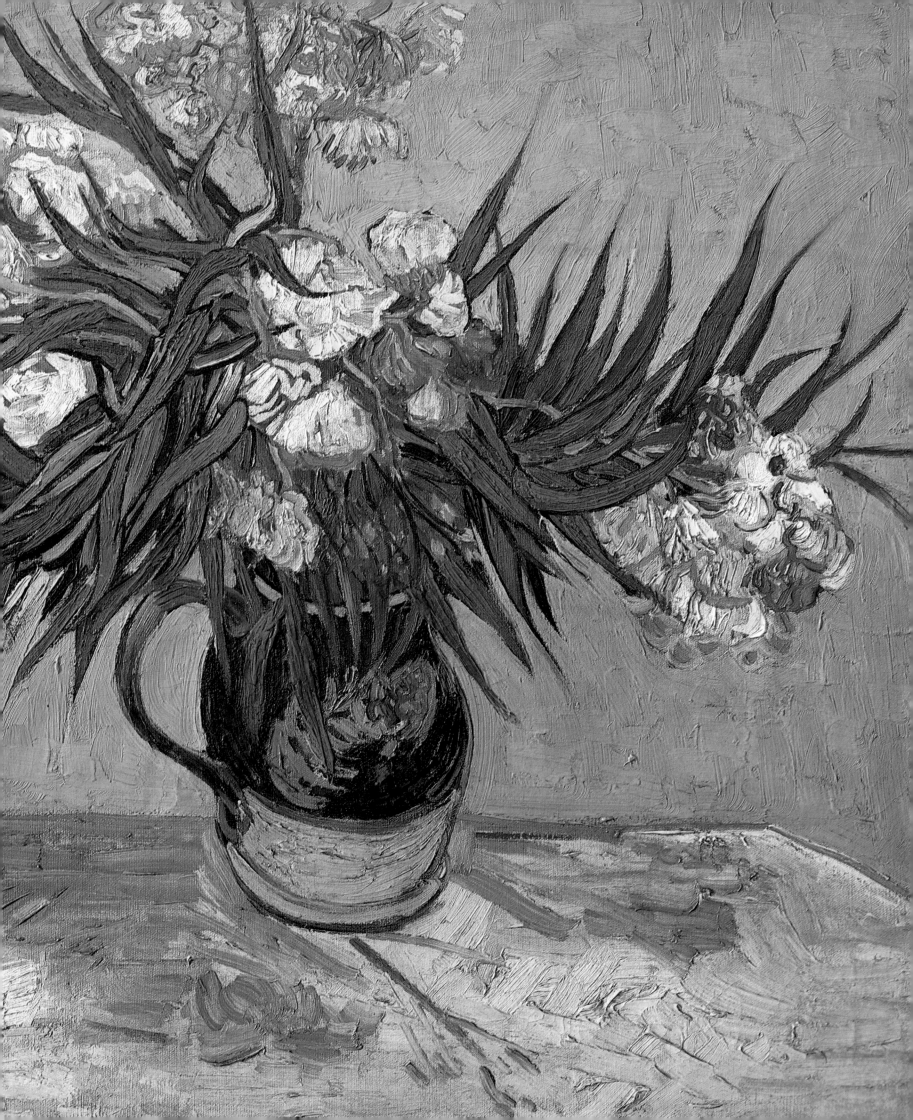

38

THISTLES ALONG THE ROAD

1888. Pencil, pen and brown ink, 24.5 × 32 cm (9⁷/₈ × 12⁵/₈ in)

National Museum Vincent van Gogh, Amsterdam,
F1466 JH1552

39

BLOSSOMING CHESTNUT BRANCHES (detail)

1890. Oil, 72 × 91 cm (28³/₈ × 35⁷/₈ in)

Foundation E.G. Bührle Collection, Zurich,
F820 JH2010

'Essentially the colour is exquisite here. When the green leaves are fresh, it is a rich green, the like of which we seldom see in the North, quiet. When it gets scorched and dusty, it does not lose its beauty,' van Gogh wrote of Arles (Letter W4, to Wil, June 1888). And in mid-August, ecstatic with the sun and heat, he reported: 'I have two studies of thistles in a vague field, thistles white with the fine dust of the road' (Letter 522, August 1888). And later: 'I am working on another study of dusty thistles, with an innumerable swarm of white and yellow butterflies.' (Letter 526, August 1888)

He also treated the subject in the independent drawing illustrated here in which the flat surface is made to pulsate with an inventive vocabulary of dashes, dots and flourishes. The crisply realized repertory of marks which van Gogh perfected in his pen and ink drawings was less easily accomplished in paint on account of the mistral. This troublesome wind gave all his attempts a 'haggard' look, van Gogh lamented, and made it 'very hard to get one's brushwork firm and interwoven with feeling, like a piece of music played with emotion' (Letter 543, September, 1888).

Unhampered by strong wind in Auvers, his painting *Blossoming Chestnut Branches* seems admirably to fulfil that aspiration. Its design is carefully controlled and integrated and it displays van Gogh's distinctive powers of conveying the sensation of flowers seen in the open air.

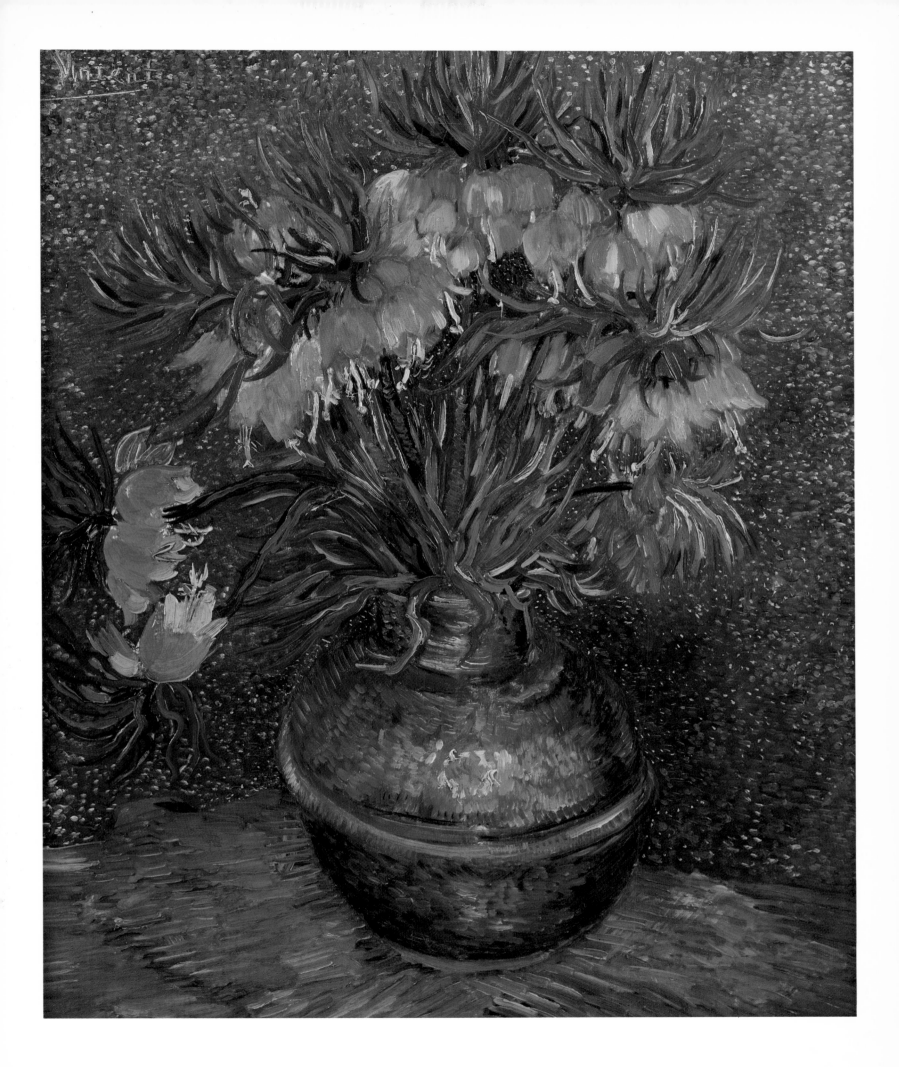

42
FLOWERING ROSEBUSHES

1889. Oil, 33 × 42 cm (13 × 16¹/₂ in)

National Museum of Western Art, Tokyo, F580 JH1679

'I still can find no better definition of the
word art than this, *L'art c'est l'homme a jouté à
la nature* [art is man added to
nature] – nature, reality, truth, but with a
significance, a conception, a character, which
the artist brings out in it, and to which he
gives expression, *qu'il dégage*, which he
disentangles, sets free and interprets.'
(Letter 130, June 1879)
'If we study Japanese art, we see a man who
is undoubtedly wise, philosophic and
intelligent, who spends his time doing what?
In studying the distance between the earth
and moon? No. In studying Bismarck's
policy? No. He studies a single blade of grass.
But this blade of grass leads him to draw
every plant and then the seasons, the wide
aspects of the countryside, then animals, then
the human figure. So he passes his life, and
life is too short to do the whole.
Come now, isn't it almost a true religion
which these simple Japanese teach us, who
live in nature as though they themselves
were flowers?
And you cannot study Japanese art, it seems
to me, without becoming much gayer and
happier, and we must return to nature in
spite of our education and our work in a
world of convention.' (Letter 542,
September 1888)

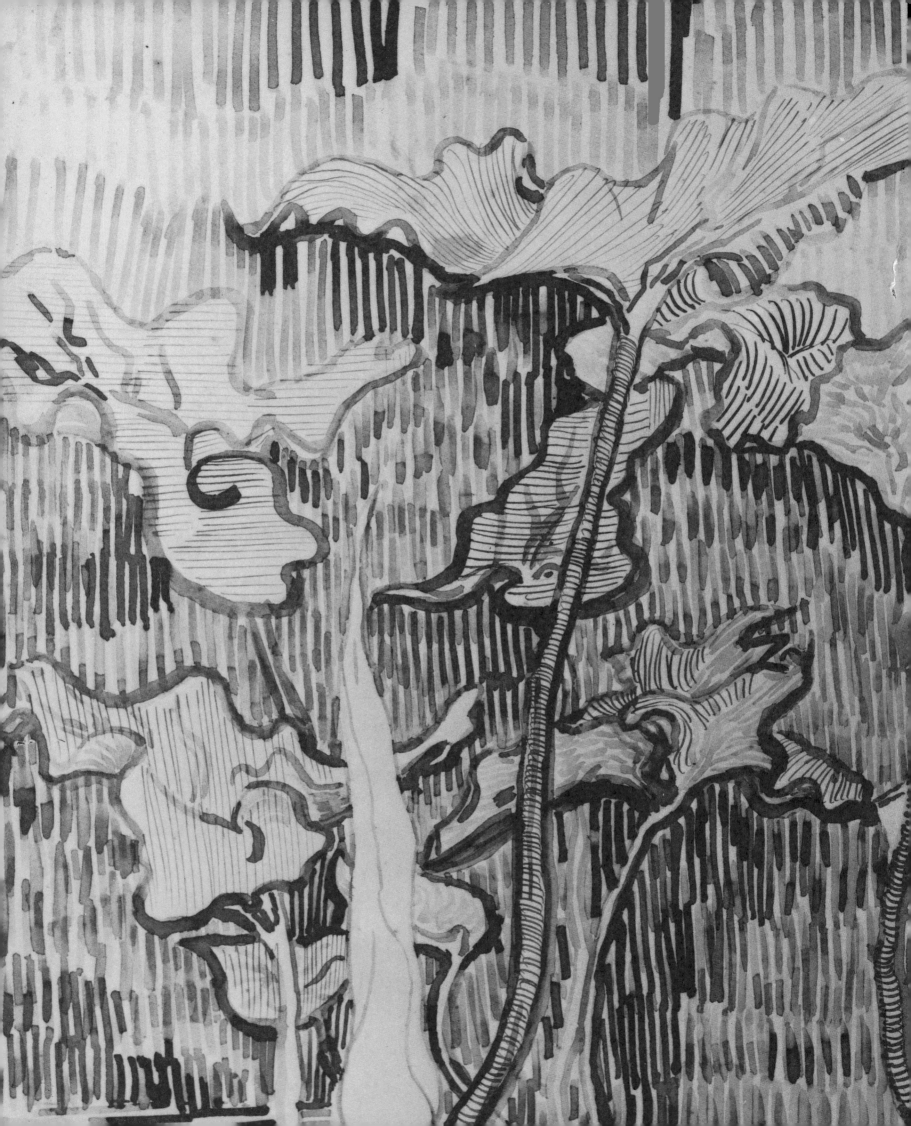